MODELING THE HEAD IN CLAY

Also by Bruno Lucchesi and Margit Malmstrom
TERRACOTTA: The Technique of Fired Clay Sculpture

MODELING THE HEAD IN CLAY

Sculpture by BRUNO LUCCHESI Text and Photographs by Margit Malmstrom

WATSON-GUPTILL PUBLICATIONS/NEW YORK

Copyright © 1979 by Bruno Lucchesi and Margit Malmstrom

First published 1979 in the United States and Canada by Watson-Guptill Publications,
a division of Billboard Publications, Inc.,
1515 Broadway, New York, N.Y. 10036

Library of Congress Cataloging in Publication Data
Lucchesi, Bruno, 1926 –
 Modeling the head in clay.
 Bibliography: p.
 Includes index.
 1. Head in art. 2. Modeling. 3. Sculpture—
Technique. I. Malmstrom, Margit. II. Title.
NB1932.L8 1979 731'.74 79-350
ISBN 0-8230-3098-9

Manufactured in U.S.A.

10 11 12/95 94 93 92

*This book is dedicated
by the artist to Carlo and Paul
and by the author to Sabu.*

ACKNOWLEDGMENTS
We would like to thank the Forum Gallery,
New York, for making many of the photographs
of the artist's work reproduced on pages 10–25
available for publication. The photographers
are: Marvin Bolotsky, Edith Kroll, Walter
Rosenblum, and Stefano Sabella.

 Thanks also to Marcella Schumann for her
special and much appreciated help in developing
the film for the demonstration sequences.

CONTENTS

Bruno Lucchesi was born in 1926 in the village of Fibbiano, high in the mountains of Tuscany, in the province of Lucca, Italy. His family, like all the villagers, were farmers and shepherds; they raised the food they ate and made the clothes they wore, and as a boy Bruno took his turn on the steep mountainsides to tend the sheep. But young Lucchesi's artistic gifts were early recognized and he went to study art in Lucca and later in nearby Florence. When not in school, Bruno prowled the streets and museums of Florence and learned by heart the lessons of the greatest masters of Renaissance art. He was especially drawn to the architecture of Brunelleschi and Alberti, the sculpture of Tino di Camaino and Donatello, and the work of the Mannerist painters Pontormo and Il Rosso.

In 1957 Lucchesi came to the United States, where his sculpture was a radical departure from what was being seen at the time. His work springs directly from the nourishing Tuscan soil and the long tradition of Italian Renaissance art. It is realistic, approachable, understandable, and executed with consummate skill. It is beautiful in its grace of line and expression. And, in addition, it has an intimacy and a sense of pathos and humor that are completely contemporary. The excellence of Lucchesi's work was instantly recognized, and over the years his sculptures have been added to the collections of the Whitney Museum of American Art, The Brooklyn Museum, the Dallas Museum of Fine Arts, The John and Mabel Ringling Museum of Art in Sarasota, Florida, and The Pennsylvania Academy of the Fine Arts, among others. His work is also well represented in many private collections, among them the Joseph H. Hirshhorn Collection and the Albert A. List Collection. He has received awards from the National Academy, which elected him Member in 1975, the National Arts Club, and the Architectural League, and he was a Guggenheim Fellow in 1962–63.

Lucchesi is perhaps best known for his smaller figures and his genre sculptures, but he also does many major commissioned pieces that are lifesize and larger. Among these are his heroic-size bust of the poet Walt Whitman, installed in 1971 in Arrow Park, Monroe, New York, and—most recently—a heroic-size statue of Sir Walter Raleigh commissioned by the city of Raleigh, North Carolina, installed in 1976.

Lucchesi lives in New York, where he takes time out from creating new work to teach packed classes at the New School.

The sculpture of Bruno Lucchesi may be seen on permanent display at the Forum Gallery in New York, which has been his exclusive dealer since 1960.

10

MOTHER AND CHILD.
Original clay relief,
66" x 39" (167.6 x 99 cm).
Photo Malmstrom

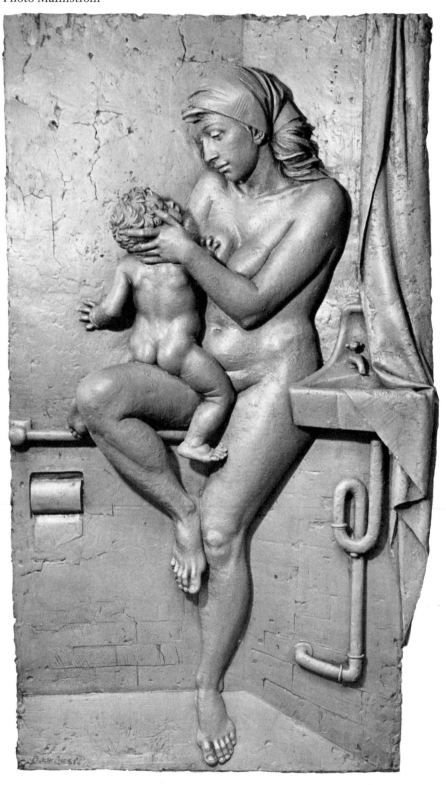

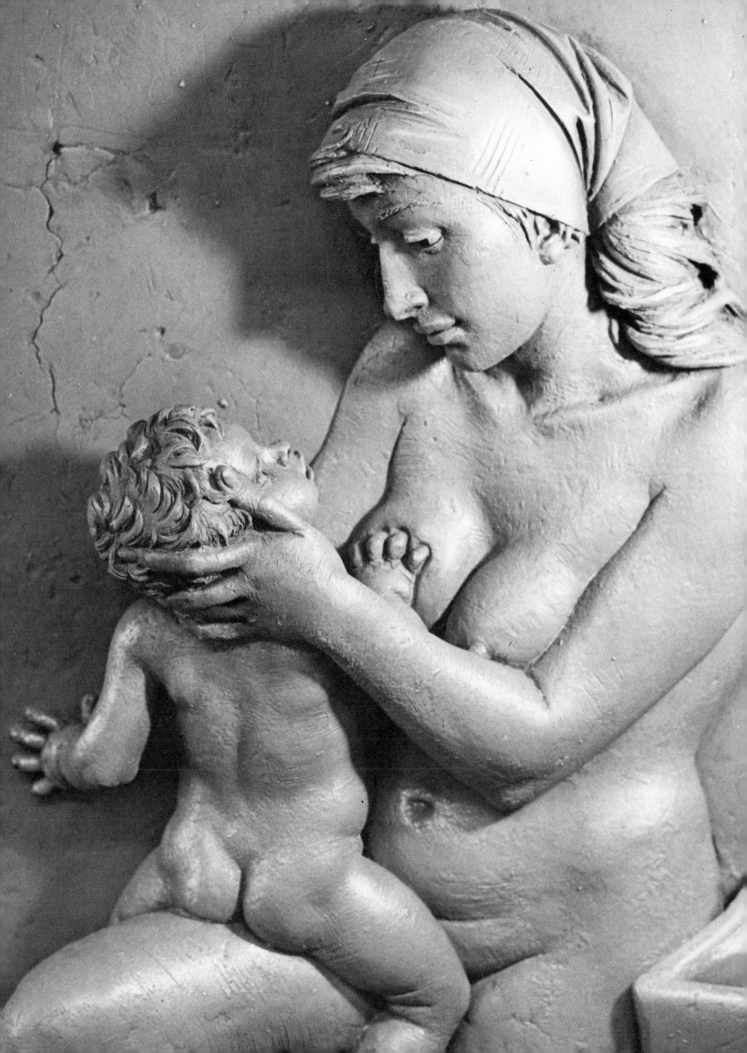

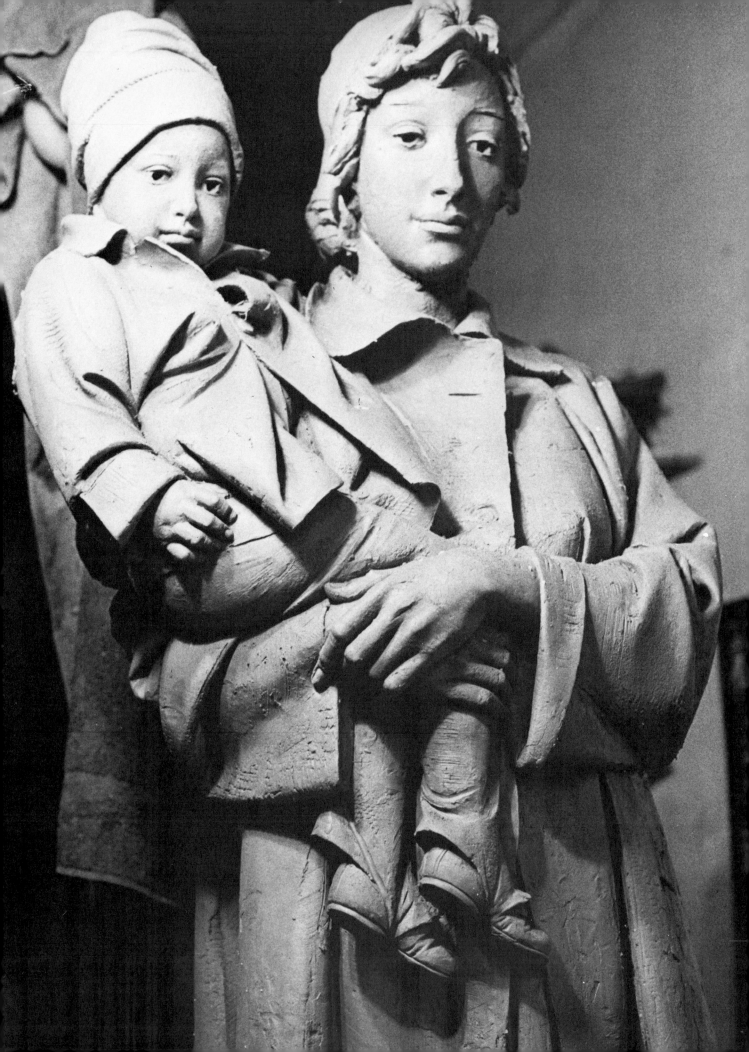

MOTHER AND CHILD.
Original clay, lifesize.
Photo Kroll

WALT WHITMAN.
Bronze, 5 feet (1.45 m) high.
Arrow Park, Monroe, New York.
Photo Sabella, courtesy
Forum Gallery, New York

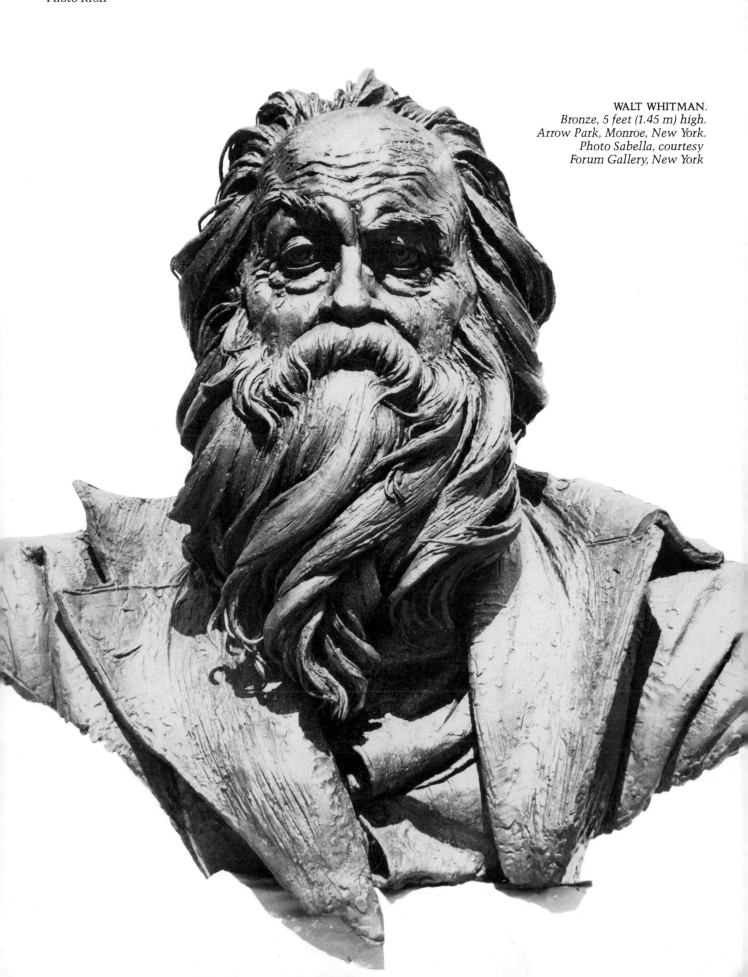

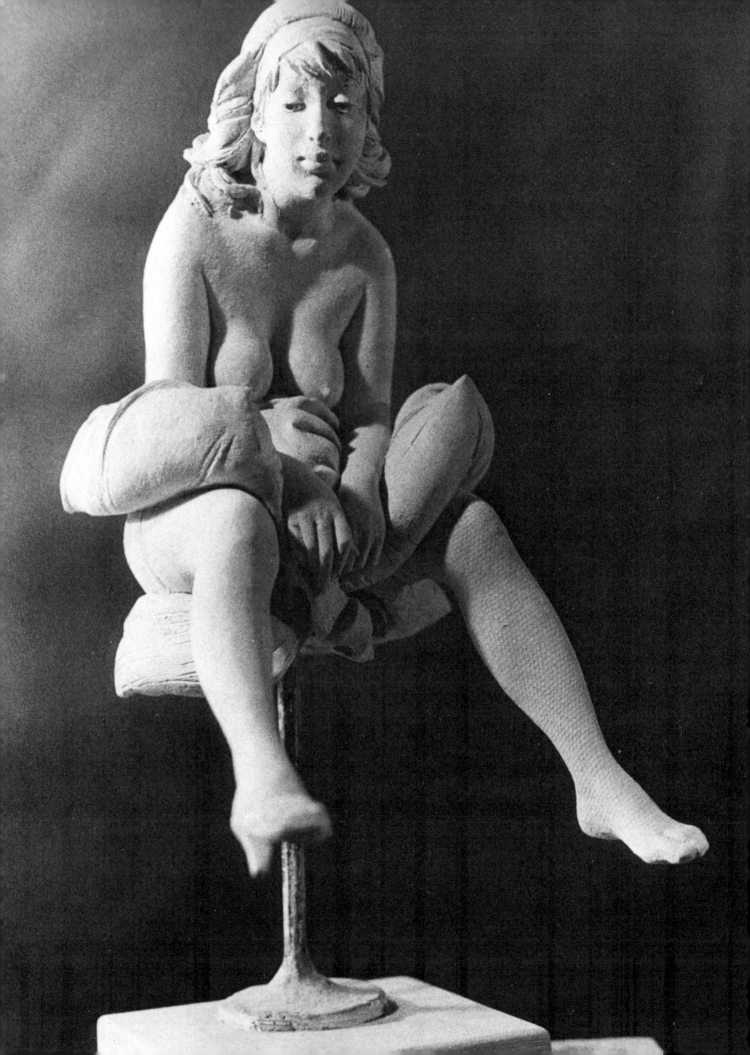

SITTING PRETTY.
Terracotta, 12" (30.5 cm) high.
Photo Kroll

LOOSE STRAP.
Terracotta, 12" (30.5 cm) high.
Photo Kroll

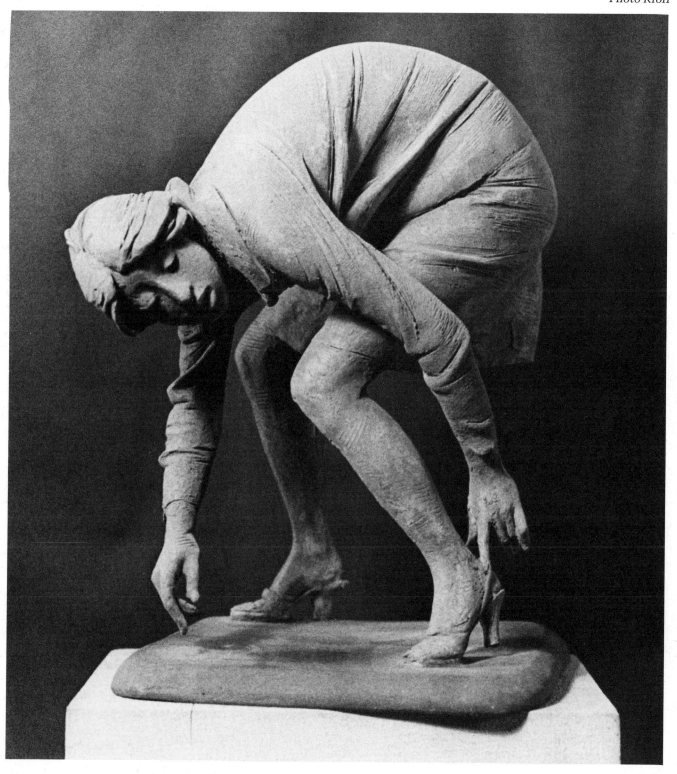

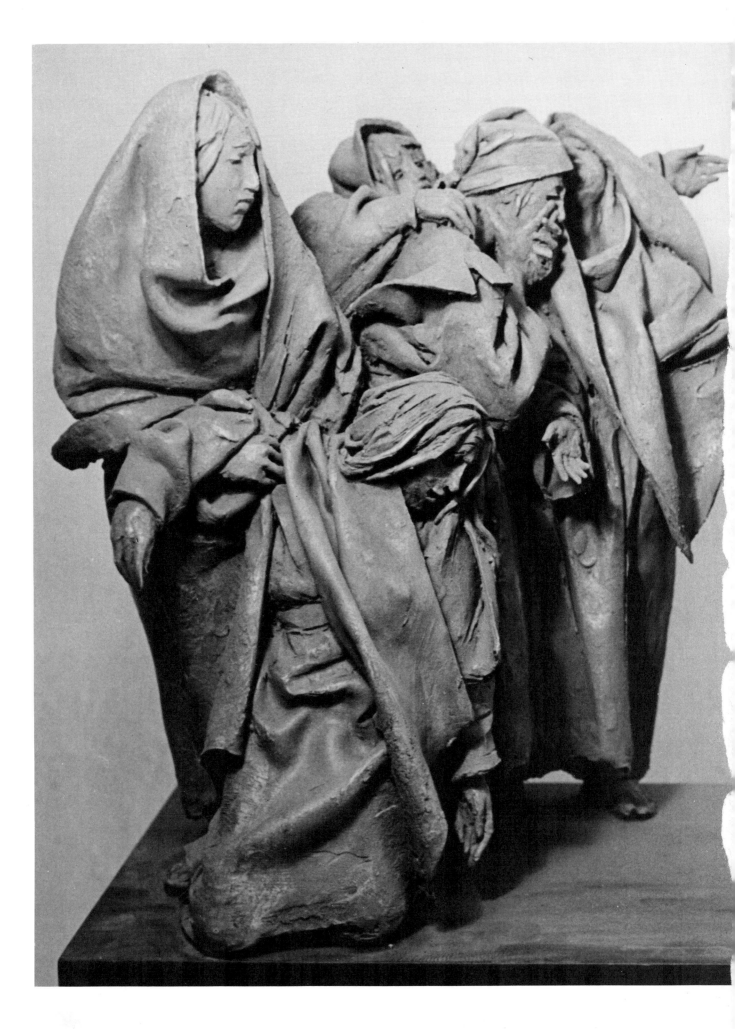

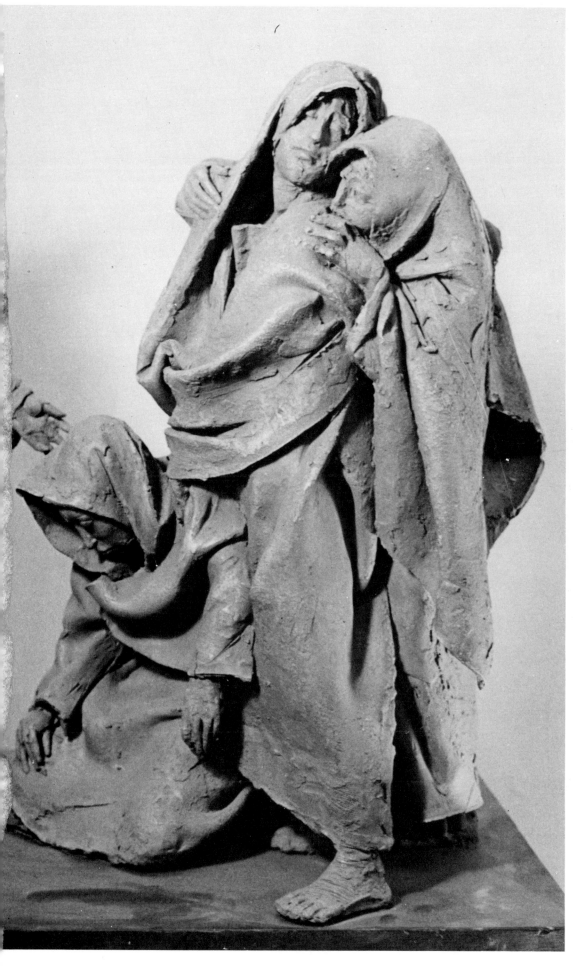

TROJAN WOMEN.
Terracotta,
18" x 27" (45.7 x 68.6 cm).
Photo Malmstrom

PENSIVE WOMAN.
Bronze, 12" (30.5 cm) high.
Photo courtesy Forum Gallery,
New York

HAMMOCK.
Bronze (detail), 46" x 85" (116.8 x 215.9 cm).
Photo courtesy Forum Gallery, New York

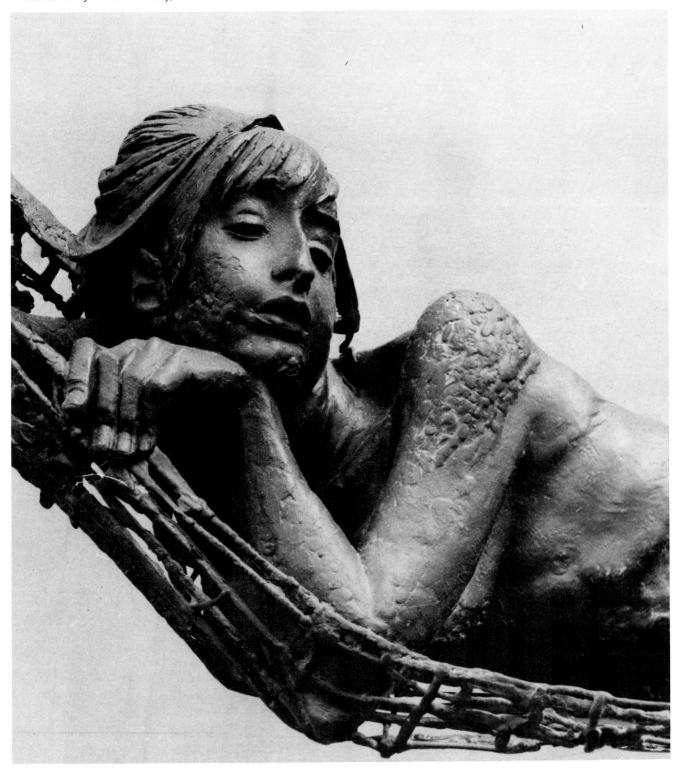

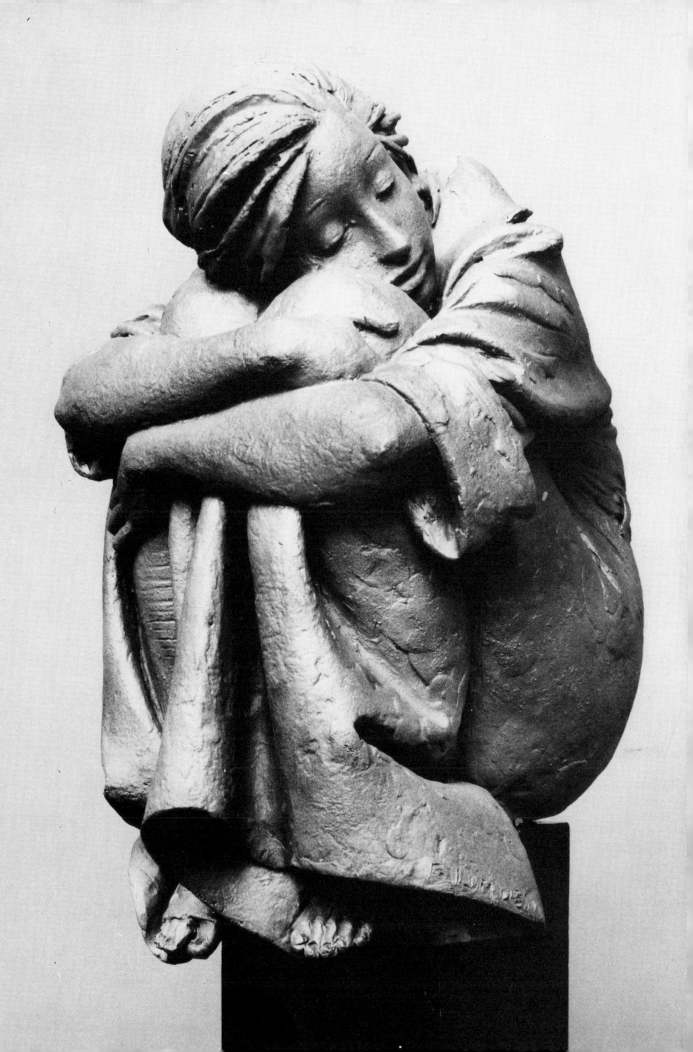

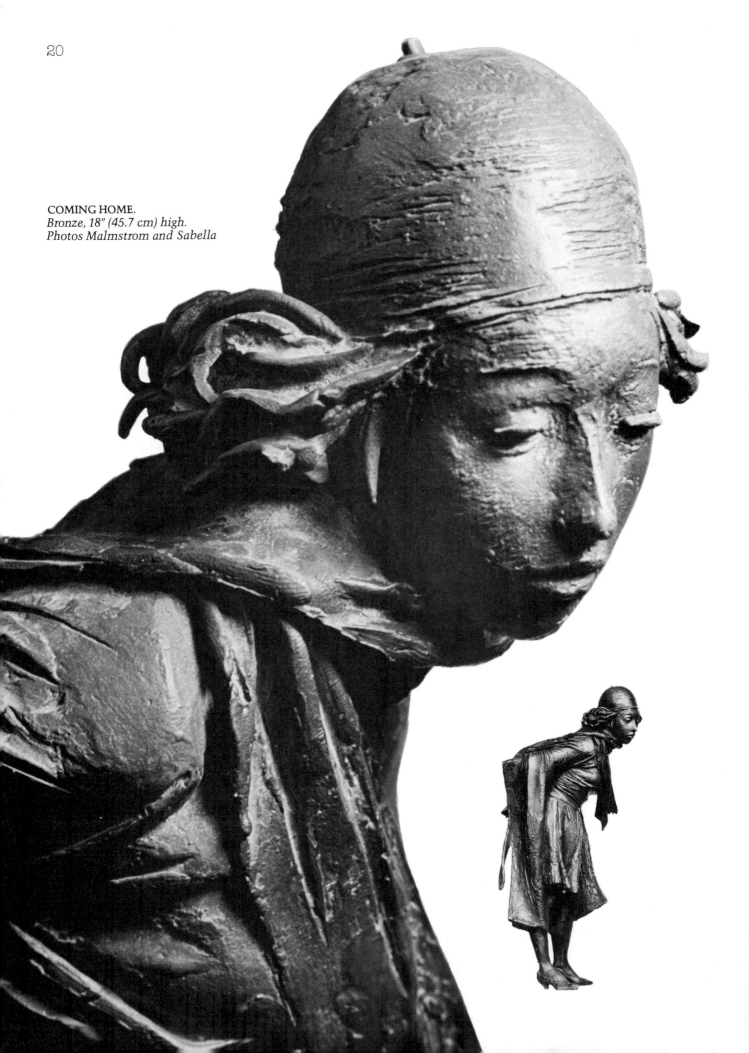

20

COMING HOME.
Bronze, 18" (45.7 cm) high.
Photos Malmstrom and Sabella

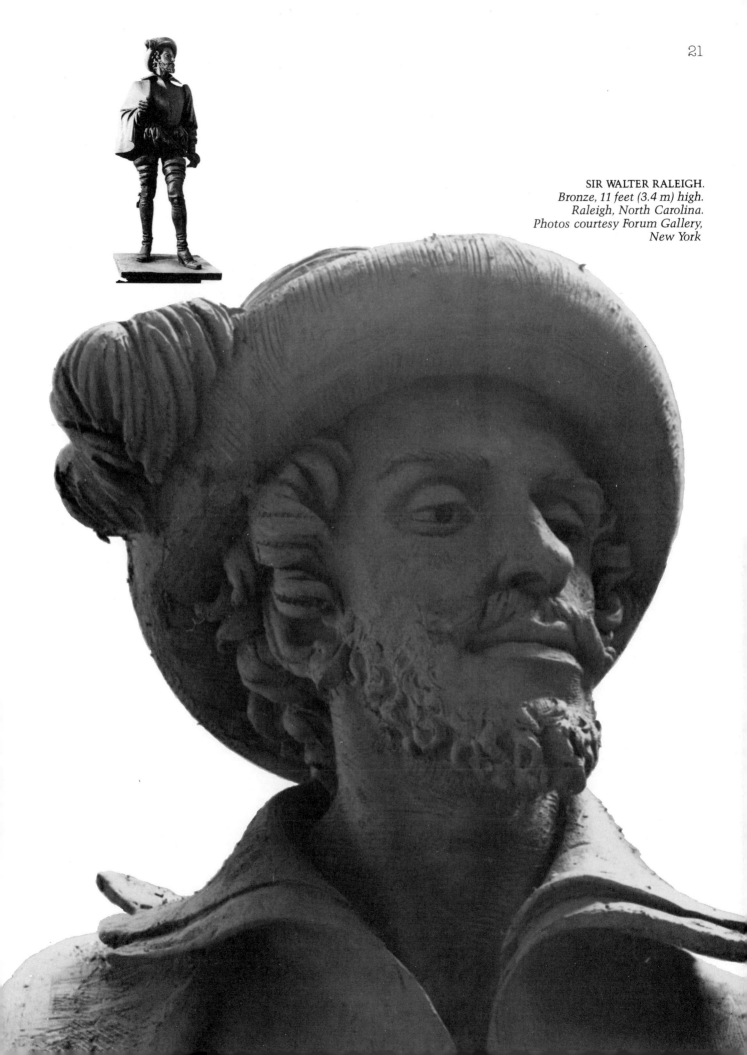

21

SIR WALTER RALEIGH.
Bronze, 11 feet (3.4 m) high.
Raleigh, North Carolina.
Photos courtesy Forum Gallery,
New York

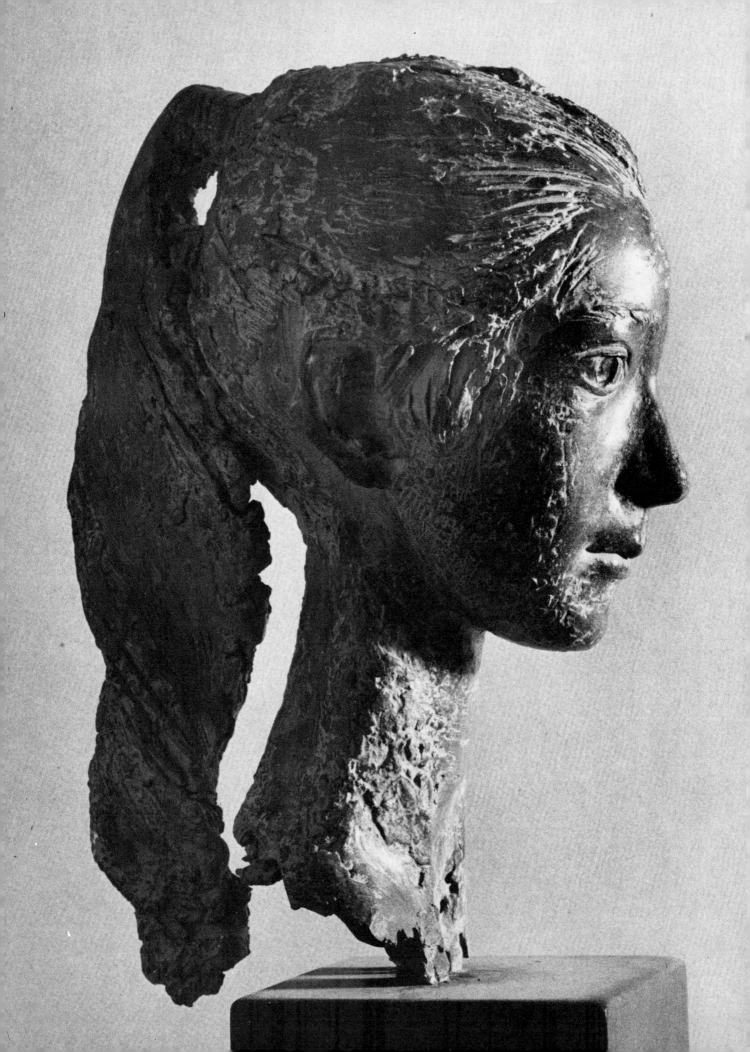

KARIN.
Terracotta, lifesize.
Private collection.
Photo Bolotsky, courtesy
Forum Gallery, New York

PUERTO RICAN BOY.
Terracotta, lifesize.
Private collection.
Photo Rosenblum, courtesy
Forum Gallery, New York

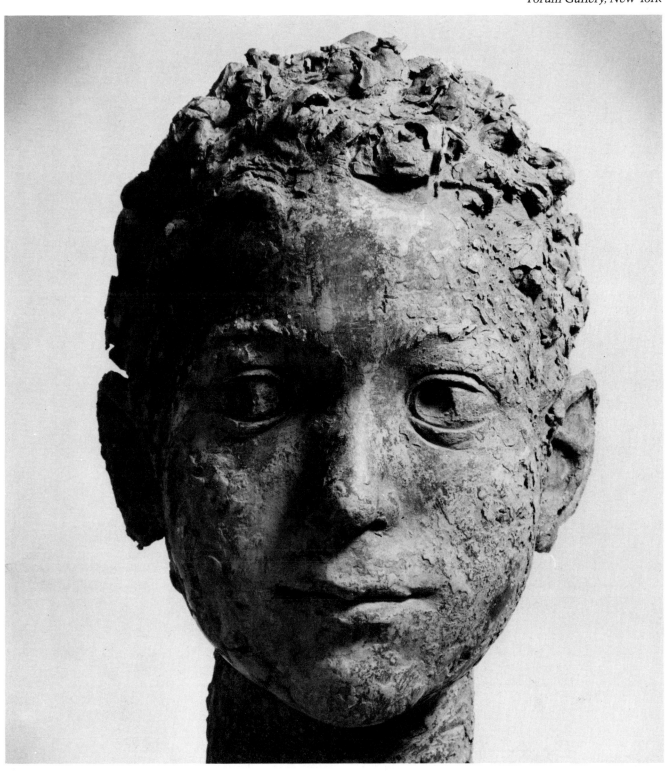

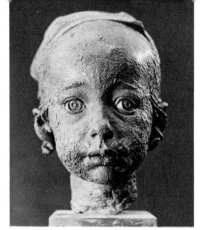

GOSSIPER.
*Terracotta relief,
32" x 18" (81.3 x 45.7 cm).
Photo Bolotsky, courtesy
Forum Gallery, New York*

BOY FROM WILLIAMSBURG.
*Terracotta, lifesize.
Photo Malmstrom*

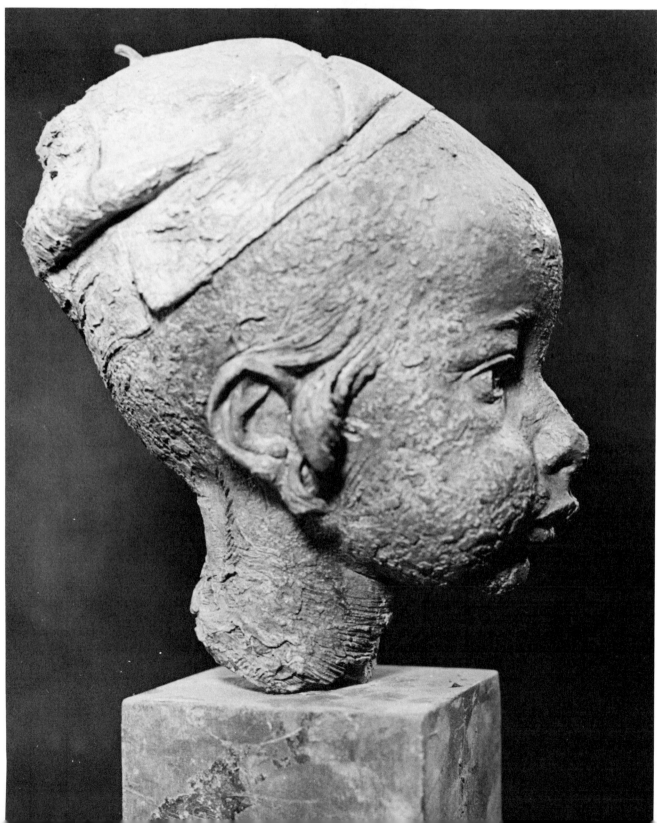

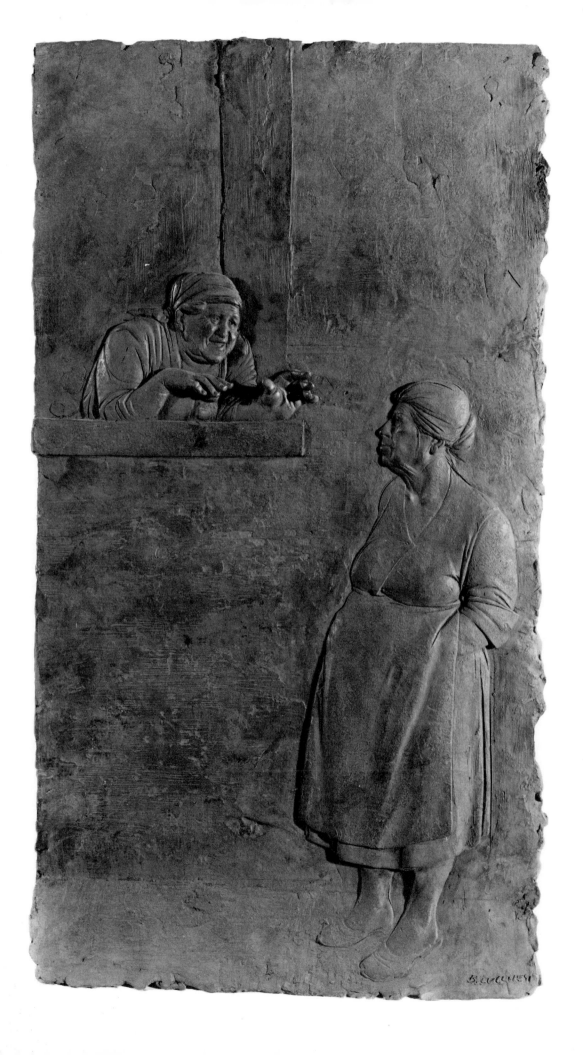

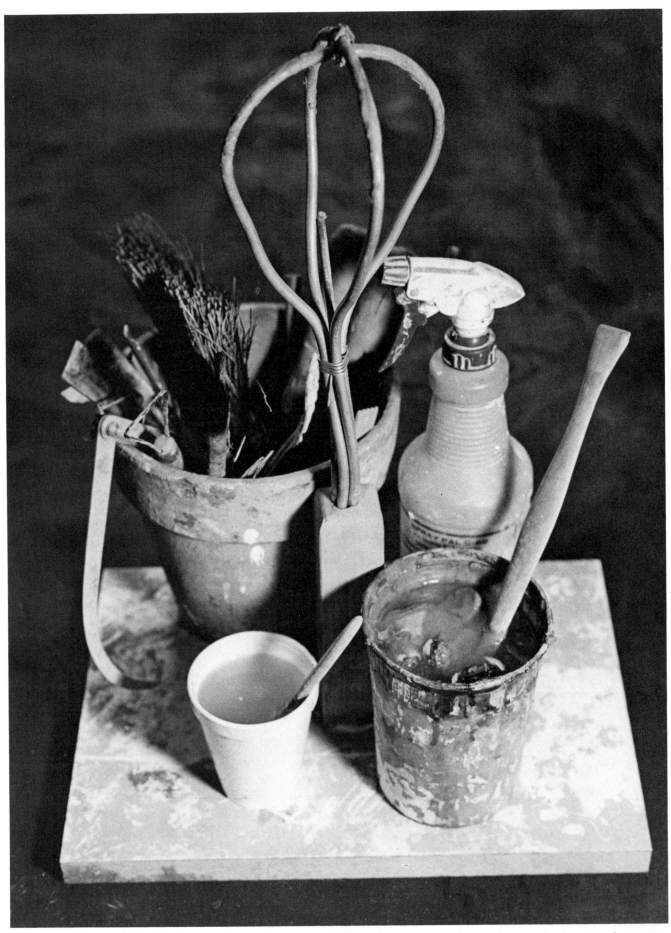

Grouped around this head armature are a flowerpot containing modeling tools, brushes, and a pair of calipers; a plant mister; a plastic container filled with slip; a Styrofoam cup filled with water.

Before we begin the demonstration, let's take a look at the tools and materials we'll be using to model a head in clay. (Sculpture suppliers as well as casting and firing services may be found under "Suppliers" at the back of this book.)

CLAY

The most important thing, of course, is the clay itself. Mr. Lucchesi will be using the same clay that goes into his terracotta sculptures, a moist (water-based) red modeling clay with no grog (finely ground fired clay that is added to the clay body, giving it extra strength and a gritty texture, used by potters). Any moist, grog-free modeling clay can be used for the techniques we will be covering. If you wish to take full advantage of this book, do not use an oil-based clay, as Lucchesi's approach relies heavily on water and brushwork, which are suited to water-based clay only.

Modeling clay comes wrapped in plastic, moist and ready to work (unless you buy dry clay, to which you must add water). Once you open the wrapping, the clay will begin to dry out. If you are working with a substantial amount of clay, you may find it more convenient to replace its wrapping with a sturdy plastic trash-can liner and place it in a plastic trash can with a lid. If the clay gets too dry in its wrapping or container, simply lay a wet towel on top of it before closing up the plastic.

The same holds true for your sculpture: you must keep it wrapped in damp cloths and plastic between work sessions. If the clay gets too dry, increase the wetness of the wrapping cloths and make sure that the plastic is tied securely at the bottom with a string to keep the air out and the dampness in. Conversely, if the clay is too wet, leave off the cloths and cover it with plastic only. You can also leave the plastic open at the bottom, or you can let the clay stay completely uncovered overnight so that it will have a chance to dry out a bit.

Casting. If you intend to have your finished sculpture cast, you do not have to worry about what kind of armature you use or how you apply the clay: the mold will pick up the surface of the sculpture only; what is inside and how it is con-structed do not matter. There are two kinds of molds that can be made on your sculpture: an *inflexible* plaster waste mold ("waste" because the mold must be broken in order to remove the cast piece) and a *flexible* rubber (or latex or silicone) mold. A plaster waste mold, because it is rigid, can only be made from a moist, and therefore yielding, original; a flexible mold may be made from either a moist or a dry surface. A plaster waste mold is relatively inexpensive, but because it must be broken it only produces a single casting; a flexible mold is more expensive but can produce many castings.

This digression into casting procedures is to alert you to the fact that if you wish to make a plaster mold from your finished sculpture, you must not let it dry out. Once it is dry, you'll have to make a rubber mold.

Firing. If you intend to fire your finished sculpture in a kiln, the armature must be removed before firing, and in building up the clay you must be careful not to allow any air pockets to form, as the gases that accumulate during the firing process will be trapped and cause the piece to break. Ideally, any sculpture that is to be fired should be hollow, with adequate vent holes to allow the gases to escape, and with as thin a clay wall as is consistent with the strength necessary to support the weight of the piece.

The best support for a large head is a commercial head armature with an aluminum wire "egg" that will support the clay properly. But if you fill the "egg" with clay, as you are supposed to do, you will not be able to get the finished sculpture off the armature and therefore you will not be able to fire it. To accommodate a head armature to the needs of making a sculpture that can be fired, simply stuff the "egg" with newspaper and cover it with a paper bag, twisting the bottom around the shank (see Steps 2 and 3 in the demonstration section). When the modeling is almost complete: (1) slice the head in half, side to side, and remove the two halves from the armature; (2) scoop out both halves until you have a clay wall about ¾" thick all the way around; (3) score the edges, apply slip (very wet clay, the consistency of heavy cream), and "glue" the halves back together. The head should be

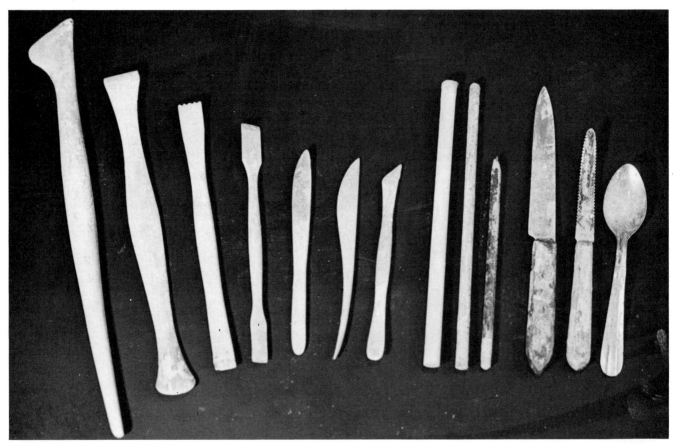

This selection of modeling tools includes, at right, pieces of wooden doweling, a pencil, paring knives, and a teaspoon—in short, whatever odds and ends Lucchesi has lying around the studio.

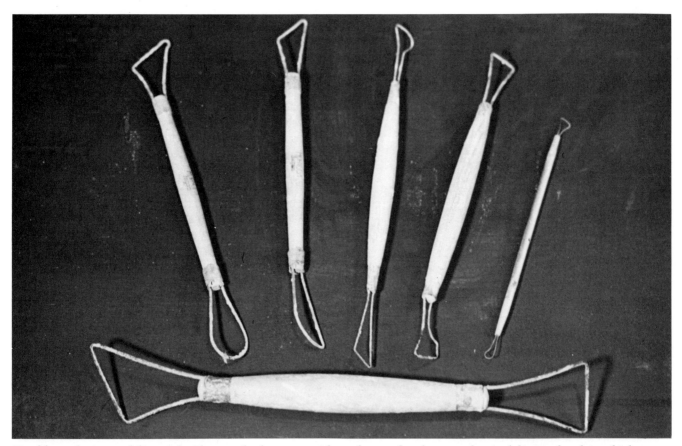

Double-end wire modeling tools. These tools also come with one loop end and one regular modeling tool end, in which case they are called single-end wire modeling tools. The tool on the extreme right has an aluminum shank and is the most delicate wire-end tool available.

left lying under plastic until the seam has knit (overnight should do it), then it may be propped up on a rod or pole anchored to a base for further work. Be sure you also support the head with blocks of wood under the neck or shoulders, because the pressure of the upright support against the seam at the top of the head can cause the two halves to break apart. When you've got the head securely upright and well supported, finish the modeling. Then let it dry out thoroughly (until the clay changes color and becomes bone dry, which should take about a week). After the piece is bone dry, it may be fired in any ceramics kiln. A low-temperature bisque firing of about cone 05 (Orton) is recommended, as the higher the firing the greater the shrinkage of the clay. The temperature should be brought up gradually, over a period of about eight hours. Any water-based clay can be fired; the correct firing temperature range will be indicated by cone numbers on the container that the clay comes in.

Moist modeling clay may be purchased in 5-lb. (2.25 kg) containers from art supply stores that carry sculpture supplies, and from sculpture and pottery suppliers, where you can get larger 25-lb. (11.4 kg) and 50-lb. (22.65 kg) quantities.

ARMATURE
We have mentioned that the most convenient support for a head is a head armature. In his demonstration, Lucchesi uses a length of brass curtain rod, bent at the top to hold the clay and anchored to a base at the bottom. But we recommend that you work on an armature that has been specifically designed for the purpose. Head armatures come in a range of sizes from 8" (20.3 cm) to 24" (61 cm) high. For a lifesize head, you'll need a lifesize armature, which is 18" (45.7 cm) or 20" (50.8 cm) high, depending on the supplier. If you intend to cast your sculpture, pack the clay firmly into the wire "egg," but if you want to fire it, stuff newspaper into the "egg" and build the clay around what will eventually be a hollow core, as outlined under "Firing" in the preceding section on clay.

Armatures may be purchased from art supply stores that carry sculpture supplies and from sculpture suppliers.

MODELING STAND
For anything as large as a lifesize head, you really should have a floor-standing modeling stand. Modeling stands have a rotating work surface that can be raised or lowered to the desired height, and some are on casters. They range in price from about $35.00 (£17) on up and are available from the larger art supply stores and from sculpture suppliers.

MODELING TOOLS
Modeling tools are made out of boxwood, maple, and rosewood, as well as plastic, and consist of a shank with a differently shaped tool at each end. They come in a vast assortment of sizes and shapes; the ends can be pointed, ball-shaped, diagonally slanted, square-tipped, curved, or serrated—in short, there is a shape for every conceivable need.

Some modeling tools have wire loops on one or both ends. These are called *wire-end tools* and also come in an array of sizes and shapes, from a delicate aluminum shank with fine steel wire ends to tools that are over a foot long.

Modeling tools are available wherever clay and sculpture supplies are sold.

PLASTER TOOLS
Steel plaster tools, also called Italian plaster tools because they are commonly made in Italy, are intended for working with plaster. But their clean surfaces and sharp edges make them excellent tools for working in clay as well. Plaster tools, like modeling tools, consist of two differently shaped ends on a single shank and come in a wide range of sizes and shapes. They are available from sculpture suppliers.

PALETTES AND SCRAPERS
The palette is essentially a potter's tool. It is made out of wood, rubber, or flexible steel and comes in a variety of shapes: oval, square, oval with one flat edge, serrated. Lucchesi uses the flexible steel palette extensively in his work, and he also makes up palettes of his own by cutting the shape he needs from the bottom of a flexible plastic container.

Scrapers, or block scrapers, as they are also called, are rigid and are used to scrape clay off

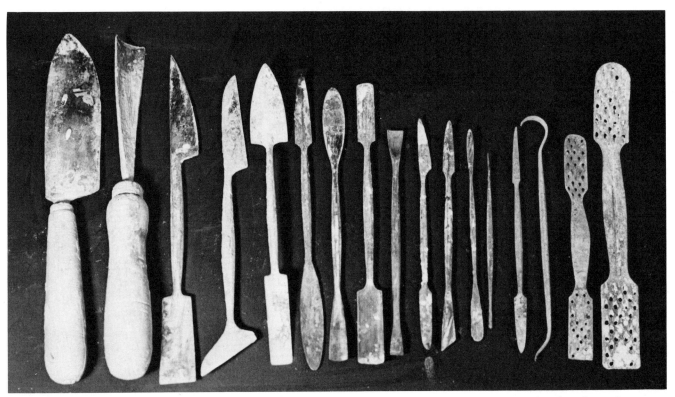

A selection of steel plaster tools, which includes, at left, a mold-maker's knife and a plaster carving chisel, and at right, two perforated steel rasps.

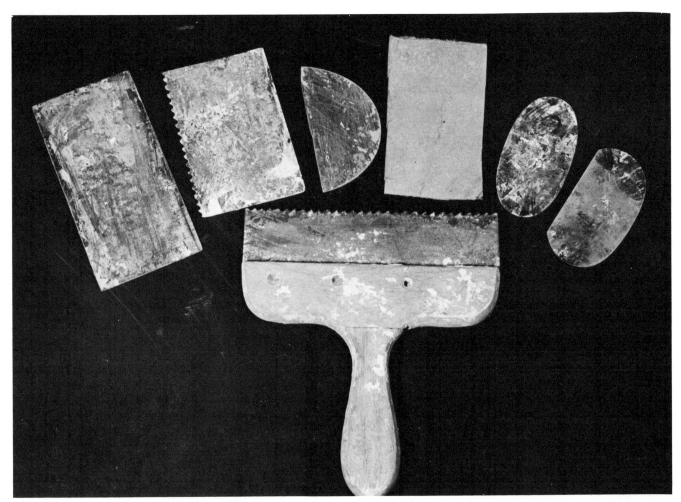

From left to right: a rigid block scraper, a block scraper with serrated edge, a flexible plastic palette cut from the bottom of a discarded container, a piece of cardboard, and two flexible steel palettes. Below is a heavy-duty serrated block scraper with a handle.

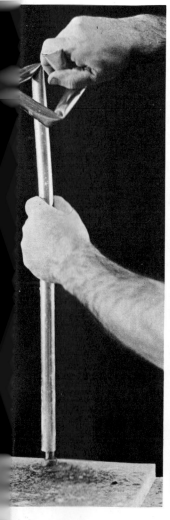

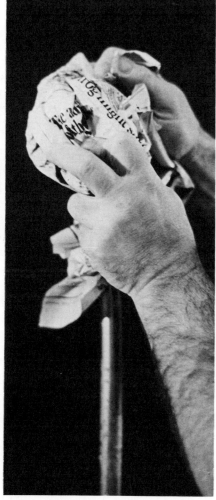

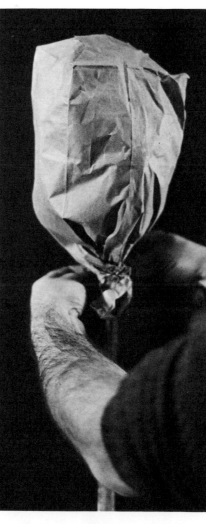

i makes his own ar-
forcing a hollow
in rod over an iron
ed to a base. He bends
the curtain rod to
e head mass. We
at you use a commer-
rmature as shown
nd Materials."

2. First he packs newspaper around the top of the armature. If you use a commercial head armature, pack the newspaper inside the wire "egg." Having a paper core will enable you to construct a head that will eventually be hollow, which is necessary if you intend to fire your sculpture (see details under "Firing" on page 27). If you do not intend to fire your sculpture, simply pack the clay directly into and around the armature.

3. He places a paper bag over the newspaper to hold it in place and twists the bottom around the rod. Again, if you use a commercial head armature and want a hollow core inside your sculpture, proceed in the same way.

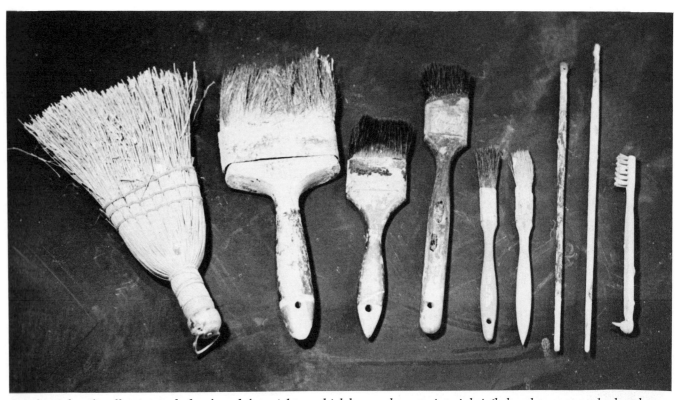

Lucchesi's brush collection includes, from left to right, a whisk broom, housepainter's bristle brushes, watercolor brushes, and an old toothbrush.

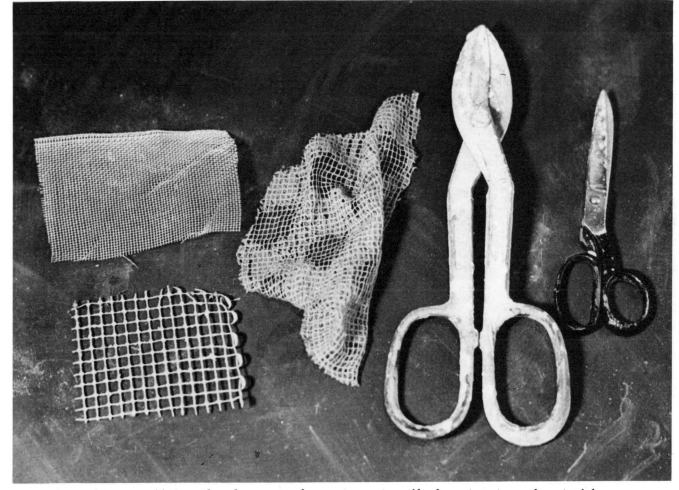

From left to right: pieces of fine-mesh and coarse-mesh screening, a piece of burlap, wire snips, and a pair of shears.

stands and bases and for slicing and cutting. There are also large plaster scrapers with serrated edges.

Palettes and scrapers are available from sculpture and pottery suppliers.

BRUSHES
Brushes of all kinds—from fine-tipped watercolor brushes to the common household whisk—are essential to Lucchesi's technique. He uses both wet and dry brushes to blend, model, and smooth the surface of the clay. You should have a good assortment of brushes on hand: pointed, square-tipped, and something with really tough bristles, like a whisk broom or a scrub brush.

Brushes are available at art supply stores, hardware stores, and five-and-dime stores.

SCREEN AND FABRIC
Lucchesi keeps wire screen of different meshes, burlap (hessian in U.K.), cheesecloth, old rags, and textured materials of all kinds on hand, as well as pieces of flexible cardboard. These are used to blend the clay, to model, and to texture the surface. Wire screen may be purchased from most hardware stores, although you may find it difficult to purchase small amounts. Burlap is available in the form of burlap bags from some hardware stores and from sculpture suppliers.

MISCELLANEOUS
Here are some additional items that you may find useful:

Calipers. Calipers are used to measure distance and check proportion; they are especially handy when doing lifesize portrait work as they allow the sculptor to accurately transfer the proportions of the sitter to the clay model. Calipers are made out of wood or aluminum and come in a range of sizes. They are available wherever sculpture supplies are sold.

C-clamps. C-clamps (g-cramps in U.K.) are used to clamp the base of the armature to the surface of the modeling stand so that you will not inadvertently knock the sculpture over as you work on it or move the modeling stand. They

come in a range of sizes and may be purchased at any hardware store.

Containers. Once you start working, you'll find that you need an assortment of containers: for wet clay, dry clay, slip, water, and your tools. Clay flowerpots make excellent tool holders, and any plastic dish or food-storage container is fine for dry clay, slip, and water. Plastic trash cans with lids are perfect for storing moist clay. A word of caution: it's best to stay away from glass, as in the heat of creation, containers may get knocked over.

Shears and Wire Snips. You'll need a sturdy pair of shears to cut fine-mesh wire screening, burlap, rags, string, etc. To cut heavier screening as well as the aluminum wire that armatures are made of you'll need a pair of wire snips. Shears are available at any hardware store, drugstore, stationery store, or five-and-dime store. Wire snips may be found in hardware stores.

Rags. Every sculptor has a rag bin, or at least a pile of old undershirts lying in a corner. Rags are indispensable to anyone who models in water-based clay, both for wrapping the sculpture so that it will stay moist and for working the clay. You should accumulate a good selection of rags, large ones for wrapping and smaller ones for texturing and modeling the clay.

Plastic. Dry-cleaning bags, trash-can liners, food-storage bags, painters' plastic drop cloths—all are handy to have around. You'll need plastic, on top of a damp cloth, to cover your sculpture between work sessions and to store your moist clay in. How much plastic you'll need depends on how many sculptures you have going at the same time and how large they are. But it's a good idea to collect as much plastic wrapping material as falls into your hands in the course of going to the cleaners and doing your shopping.

Plant Mister. A plastic plant mister is the most convenient way to wet down your sculpture while you're working on it. You can find plant misters at hardware stores, gardening suppliers, florists, and five-and-dime stores.

In the demonstration sequences that follow, Bruno Lucchesi models a lifesize head, including neck and shoulders. He did not work from a model because he did not want this to be a *particular* head. In the same way, although it is the head of a young woman, the features are strong enough so that it could just as well be that of a young man. What we wanted to demonstrate in this book was how to model *the* head, *any* head, because we feel that an artist should understand the general before attempting to capture the specific. It is for this reason that we have not branched out to show male and female, old and young, bearded and clean-shaven, etc. We felt that a single head, minutely documented, would best illustrate the range of approaches and techniques needed to model any head.

As the sequences progress, we go from showing the head as a whole to the development of individual parts, such as eyes or hair, then back again to the whole. This corresponds exactly to Mr. Lucchesi's actual working technique. It should also serve as a reminder that the growth

of the whole is more
Not only does Mr. L
one by one, but he v
as a whole, blending
tions, so that there i
movement from det
surface treatment.

You will also find
carried out more tha
blurred or obliterate
process that consists
away, smoothing ove
face, until at last eac
comes part of a harm

As you work, it's i
concept of the sculpt
poorly executed part
wise pleasing piece, a
modeled parts does n
a sculpturally satisfy
know how to model e
back and see the proj

1. Lucche
mature by
brass curt
rod ancho
the top of
support t
suggest t
cial head
in "Tools

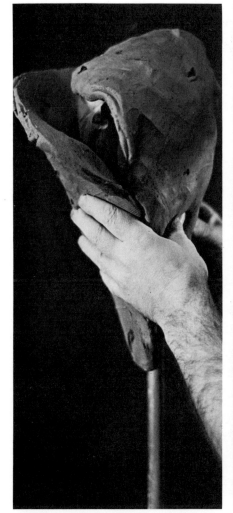 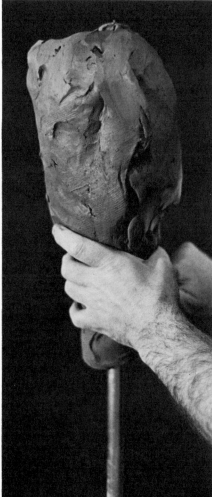 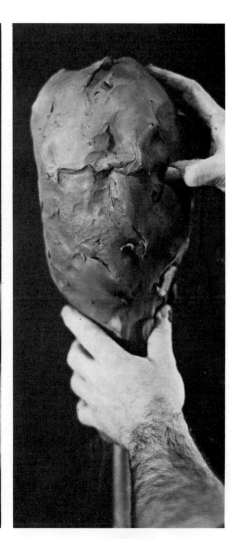

4. Now Lucchesi lays large slabs of clay over the paper core (see above). Even if he had started with clay packed into the armature instead of paper, he would add slabs of clay at this stage in order to speed up the building process and get rid of irregularities in the clay surface.

5. Where the slabs join and overlap, he works the clay together with his thumbs, pressing it around the rod to form the neck.

6. He starts to map out the features, here indicating where the eyes will be.

ROUGHING IN
THE FACE

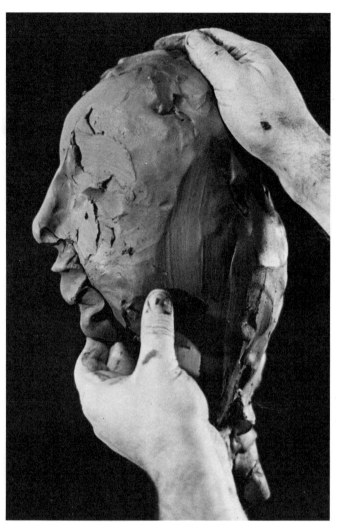

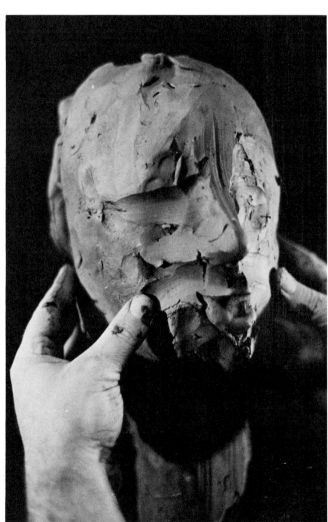

7. To quickly establish the profile, he lays a length of rolled clay down the middle of the face, from top to bottom, pushing it in with the heel of his hand to rough in the nose, lips, and chin.

8. With his thumbs, he sweeps the clay back from the midline of the face.

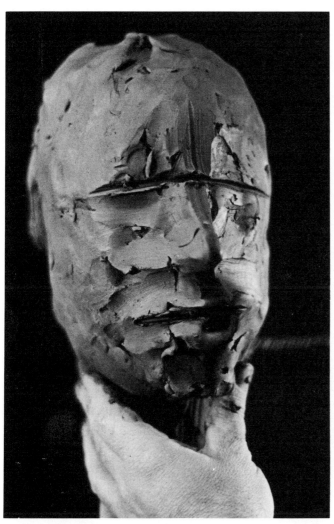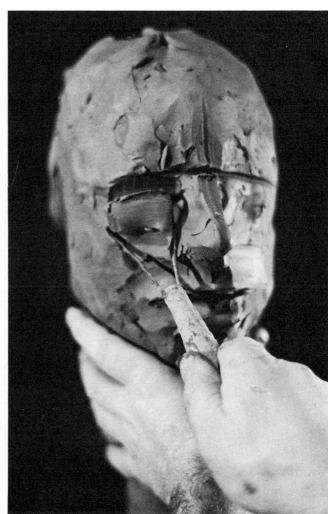

9. Now, with a wire-end tool, he draws in the line of the eyebrows and lips.

10. Then he gouges out the eye sockets with a large wire-end tool.

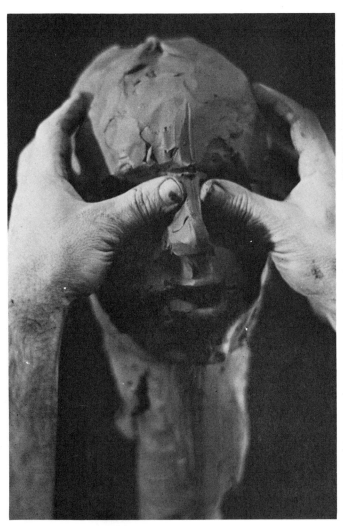 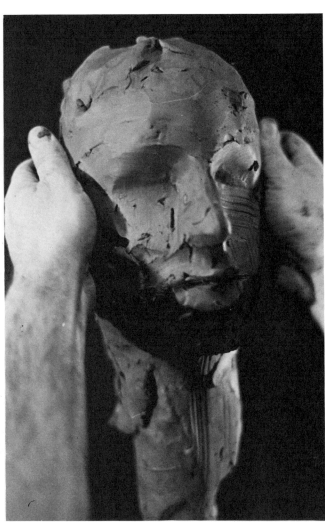

11. He presses into the sockets, sweeping his thumbs up and out from the bridge of the nose.

12. To move the modeling around to the temples and cheekbones, Lucchesi sweeps the clay back and around the facial contour with his thumbs.

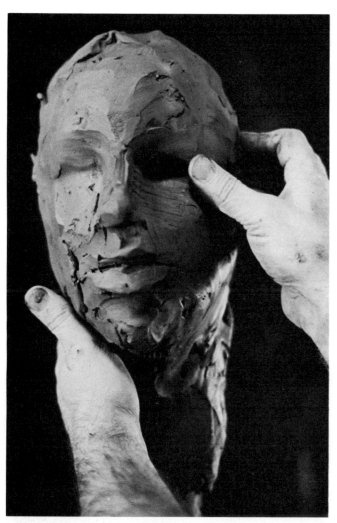 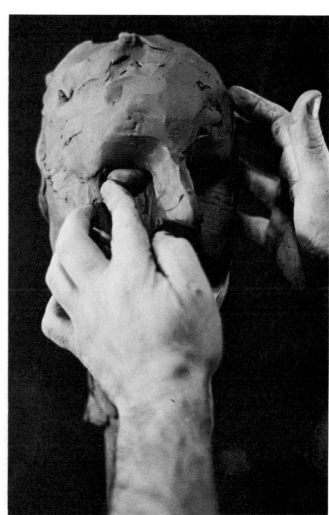

13. He depresses the eye sockets to make a cavity into which he will place the eyeball.

14. He rolls a ball of clay and places it into the socket.

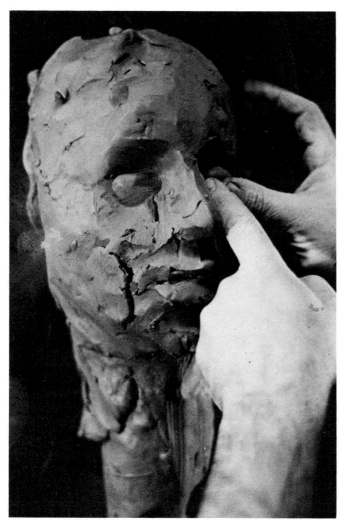 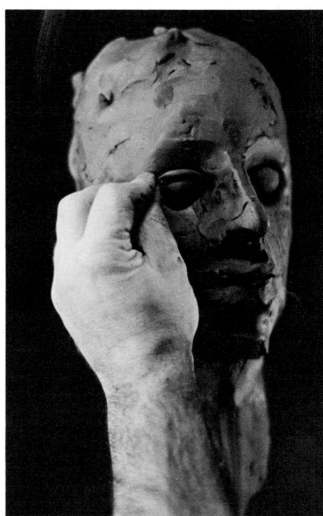

15. He gently presses the second eyeball into its socket.

16. To make the eyelid, he rolls out a small coil of clay and positions it over the eyeball (see above).

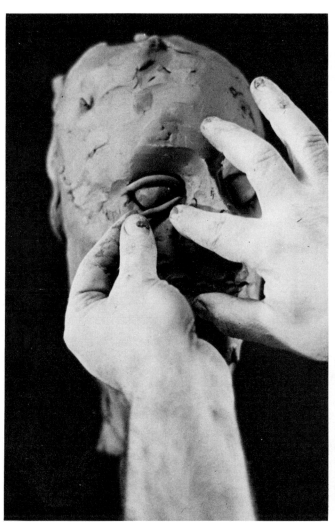 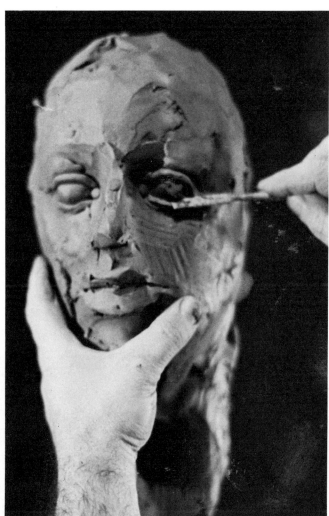

17. He rolls another coil for the lower lid and presses it into position.

18. Here Lucchesi uses a plaster tool to further define the eyelids and work the clay into the surrounding area.

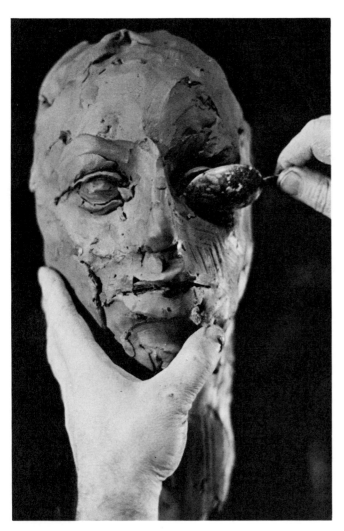 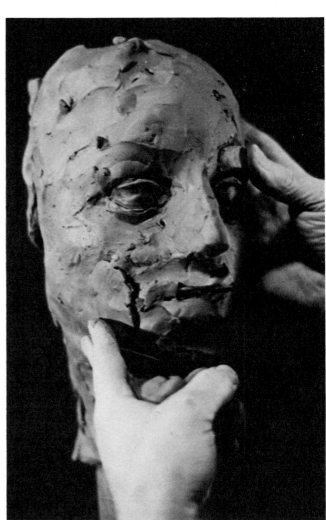

19. Whatever Lucchesi has on hand in the studio is eventually pressed into service as a modeling tool. Here he uses a spoon, which, because of its concave oval shape, is particularly well suited to shaping the eye.

20. Using a firm pressure of his thumb, Lucchesi models the upper eye area and indicates the line of the eyebrow.

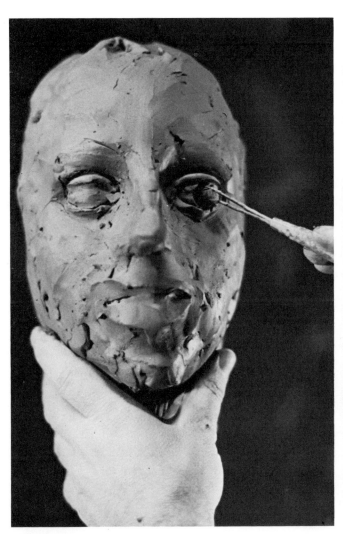

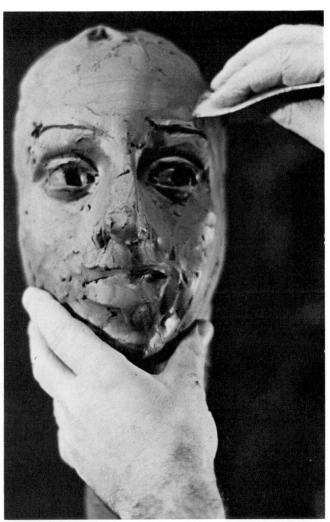

21. With an oval-shaped wire-end tool, he plucks a ball of clay out of the eyeball to make the dark part of the eye, or iris.

22. Here Lucchesi draws a flexible plastic palette, cut from the bottom of a discarded container, over the surface to blend the clay and define the planes of the face.

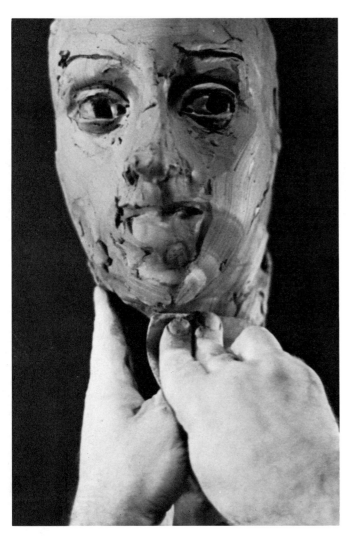

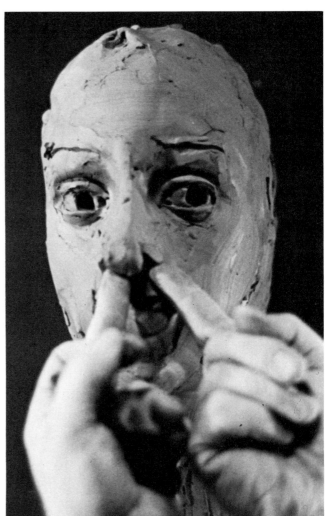

23. He pulls the palette down the cheek to the throat with a steady pressure of his fingertips, "spreading" the clay over the surface.

24. Here he uses his fingertips to press the nostril shapes out of the clay of the nose, exerting equal pressure on each side so that the nostrils will come out even.

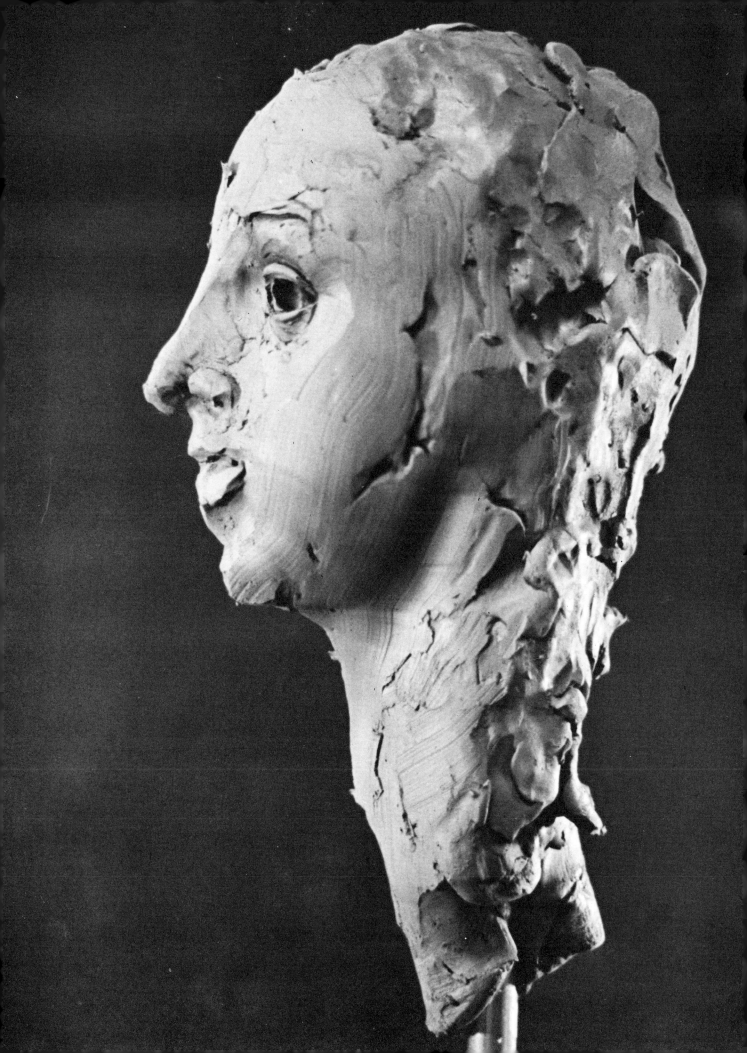

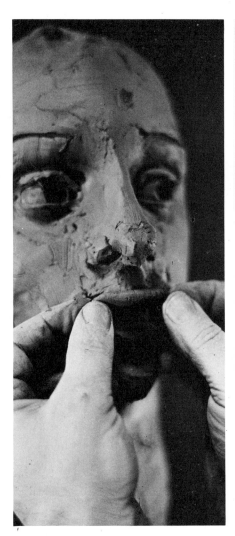 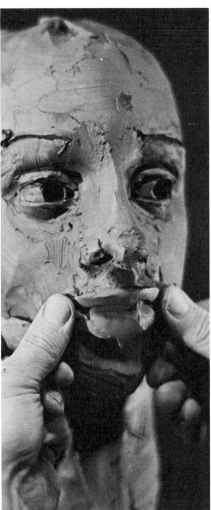 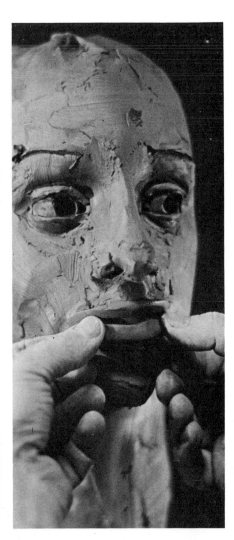

25. For the mouth, Lucchesi rolls two coils of clay, one for the upper lip and one for the lower lip. Here he presses the upper lip into position.

26. He works in the clay of the upper lip.

27. Then he places the lower lip into position.

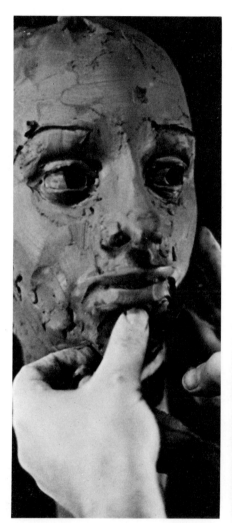 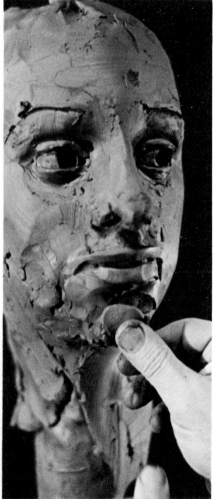 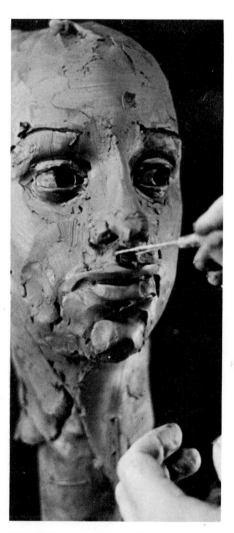

28. He presses into the clay with his thumb to form the indentation beneath the lower lip.

29. For the chin, Lucchesi pats out a small mound of clay and presses it into position, pushing into the center with his thumb to form the cleft.

30. With an oval-shaped wire-end tool he digs out the depression in the upper lip.

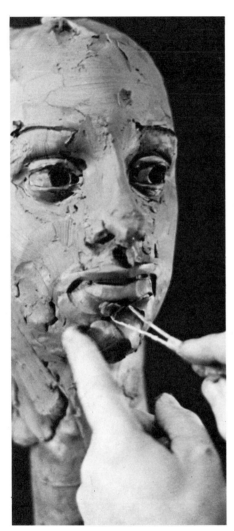

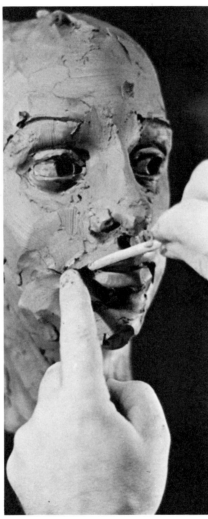

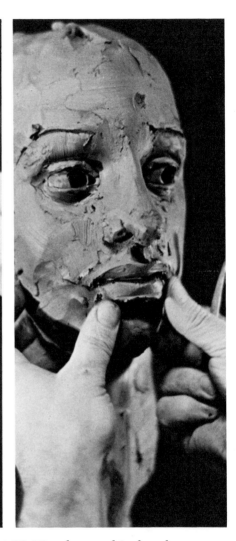

31. Here he digs out the indentation beneath the lower lip.

32. With a modeling tool, he presses indentations into each corner of the mouth.

33. Now he uses his thumbs to model the lips, here pressing his thumbnails into the clay to indicate the sharp lip line.

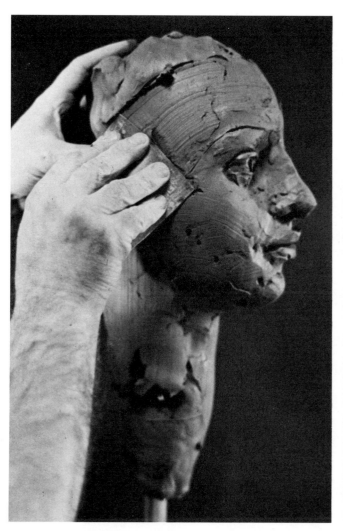 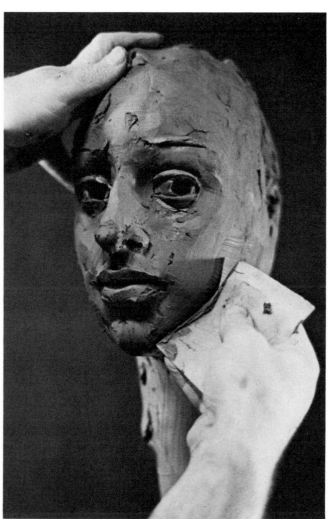

34. Again, he pulls the flexible plastic palette over the surface to "spread" the clay and define the planes.

35. He curves the palette to follow the contour of the face, here drawing it around the fullness of the cheek.

ROUGHING IN
THE EARS

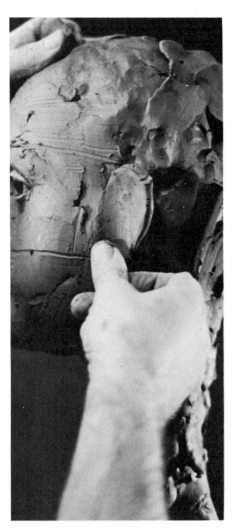 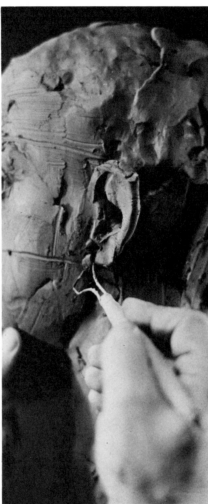 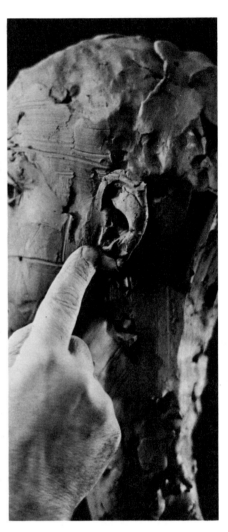

36. First Lucchesi pats out an ear-sized oval of clay, then he places it on the side of the head between the guidelines that he has drawn from the eyebrow and the end of the nose.

37. With a wire-end tool, he draws the basic S shape of the inside of the ear and carves around the fatty mound of the earlobe.

38. Here Lucchesi softens the modeling and blends the clay with his fingertip.

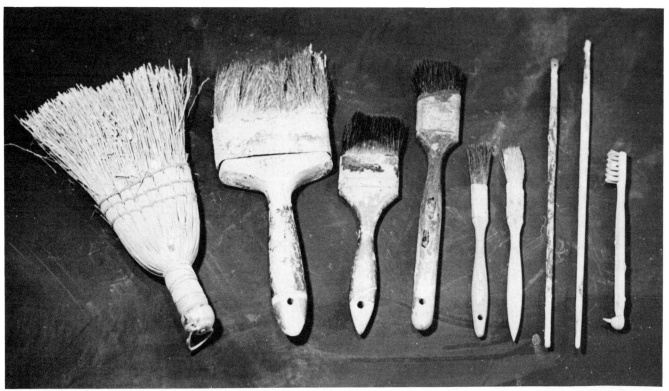

Lucchesi's brush collection includes, from left to right, a whisk broom, housepainter's bristle brushes, watercolor brushes, and an old toothbrush.

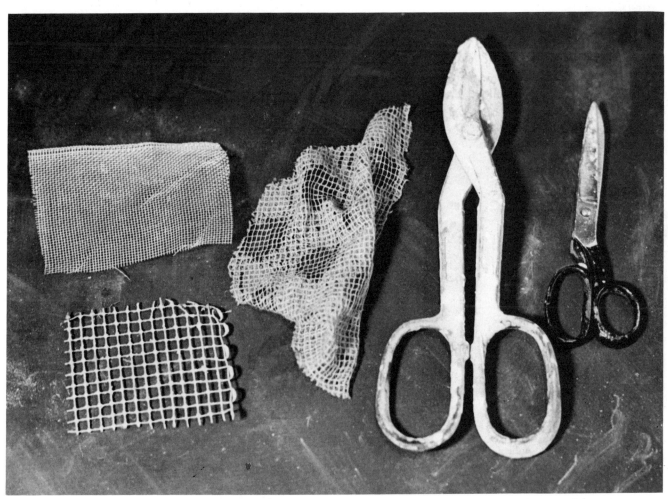

From left to right: pieces of fine-mesh and coarse-mesh screening, a piece of burlap, wire snips, and a pair of shears.

stands and bases and for slicing and cutting. There are also large plaster scrapers with serrated edges.

Palettes and scrapers are available from sculpture and pottery suppliers.

BRUSHES

Brushes of all kinds—from fine-tipped watercolor brushes to the common household whisk—are essential to Lucchesi's technique. He uses both wet and dry brushes to blend, model, and smooth the surface of the clay. You should have a good assortment of brushes on hand: pointed, square-tipped, and something with really tough bristles, like a whisk broom or a scrub brush.

Brushes are available at art supply stores, hardware stores, and five-and-dime stores.

SCREEN AND FABRIC

Lucchesi keeps wire screen of different meshes, burlap (hessian in U.K.), cheesecloth, old rags, and textured materials of all kinds on hand, as well as pieces of flexible cardboard. These are used to blend the clay, to model, and to texture the surface. Wire screen may be purchased from most hardware stores, although you may find it difficult to purchase small amounts. Burlap is available in the form of burlap bags from some hardware stores and from sculpture suppliers.

MISCELLANEOUS

Here are some additional items that you may find useful:

Calipers. Calipers are used to measure distance and check proportion; they are especially handy when doing lifesize portrait work as they allow the sculptor to accurately transfer the proportions of the sitter to the clay model. Calipers are made out of wood or aluminum and come in a range of sizes. They are available wherever sculpture supplies are sold.

C-clamps. C-clamps (g-cramps in U.K.) are used to clamp the base of the armature to the surface of the modeling stand so that you will not inadvertently knock the sculpture over as you work on it or move the modeling stand. They

come in a range of sizes and may be purchased at any hardware store.

Containers. Once you start working, you'll find that you need an assortment of containers: for wet clay, dry clay, slip, water, and your tools. Clay flowerpots make excellent tool holders, and any plastic dish or food-storage container is fine for dry clay, slip, and water. Plastic trash cans with lids are perfect for storing moist clay. A word of caution: it's best to stay away from glass, as in the heat of creation, containers may get knocked over.

Shears and Wire Snips. You'll need a sturdy pair of shears to cut fine-mesh wire screening, burlap, rags, string, etc. To cut heavier screening as well as the aluminum wire that armatures are made of you'll need a pair of wire snips. Shears are available at any hardware store, drugstore, stationery store, or five-and-dime store. Wire snips may be found in hardware stores.

Rags. Every sculptor has a rag bin, or at least a pile of old undershirts lying in a corner. Rags are indispensable to anyone who models in water-based clay, both for wrapping the sculpture so that it will stay moist and for working the clay. You should accumulate a good selection of rags, large ones for wrapping and smaller ones for texturing and modeling the clay.

Plastic. Dry-cleaning bags, trash-can liners, food-storage bags, painters' plastic drop cloths—all are handy to have around. You'll need plastic, on top of a damp cloth, to cover your sculpture between work sessions and to store your moist clay in. How much plastic you'll need depends on how many sculptures you have going at the same time and how large they are. But it's a good idea to collect as much plastic wrapping material as falls into your hands in the course of going to the cleaners and doing your shopping.

Plant Mister. A plastic plant mister is the most convenient way to wet down your sculpture while you're working on it. You can find plant misters at hardware stores, gardening suppliers, florists, and five-and-dime stores.

DEMONSTRATION: MODELING THE HEAD IN CLAY

In the demonstration sequences that follow, Bruno Lucchesi models a lifesize head, including neck and shoulders. He did not work from a model because he did not want this to be a *particular* head. In the same way, although it is the head of a young woman, the features are strong enough so that it could just as well be that of a young man. What we wanted to demonstrate in this book was how to model *the* head, *any* head, because we feel that an artist should understand the general before attempting to capture the specific. It is for this reason that we have not branched out to show male and female, old and young, bearded and clean-shaven, etc. We felt that a single head, minutely documented, would best illustrate the range of approaches and techniques needed to model any head.

As the sequences progress, we go from showing the head as a whole to the development of individual parts, such as eyes or hair, then back again to the whole. This corresponds exactly to Mr. Lucchesi's actual working technique. It should also serve as a reminder that the growth of the whole is more than the growth of its parts. Not only does Mr. Lucchesi model the features one by one, but he works over the entire surface as a whole, blending, texturing, gauging proportions, so that there is a constant back-and-forth movement from detailed modeling to overall surface treatment.

You will also find that the same procedures are carried out more than once: modeling is often blurred or obliterated and must be redefined in a process that consists of building up and carving away, smoothing over and roughening the surface, until at last each individual element becomes part of a harmonious whole.

As you work, it's important not to lose the concept of the sculpture as a whole. Although a poorly executed part can detract from an otherwise pleasing piece, a collection of carefully modeled parts does not necessarily add up to a sculpturally satisfying whole. The artist must know how to model each part *and* how to step back and see the project in its entirety.

CONSTRUCTING
THE HEAD MASS

 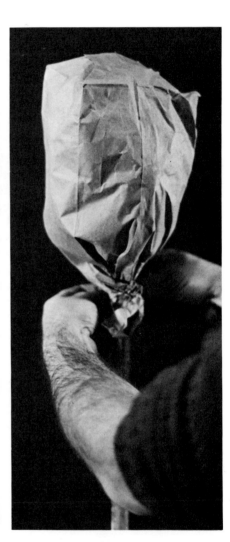

1. Lucchesi makes his own armature by forcing a hollow brass curtain rod over an iron rod anchored to a base. He bends the top of the curtain rod to support the head mass. We suggest that you use a commercial head armature as shown in "Tools and Materials."

2. First he packs newspaper around the top of the armature. If you use a commercial head armature, pack the newspaper inside the wire "egg." Having a paper core will enable you to construct a head that will eventually be hollow, which is necessary if you intend to fire your sculpture (see details under "Firing" on page 27). If you do not intend to fire your sculpture, simply pack the clay directly into and around the armature.

3. He places a paper bag over the newspaper to hold it in place and twists the bottom around the rod. Again, if you use a commercial head armature and want a hollow core inside your sculpture, proceed in the same way.

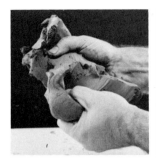

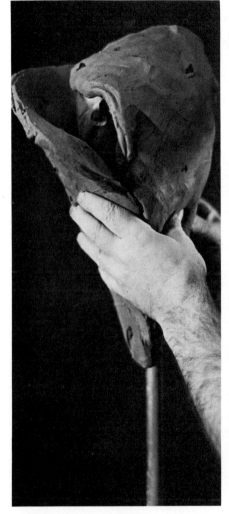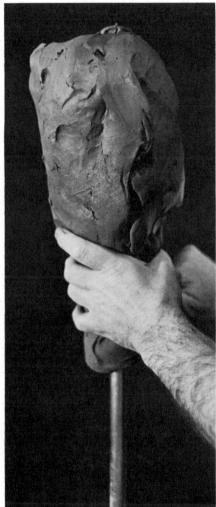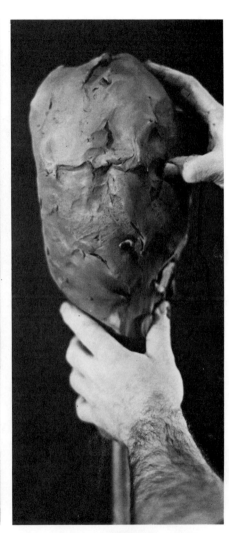

4. Now Lucchesi lays large slabs of clay over the paper core (see above). Even if he had started with clay packed into the armature instead of paper, he would add slabs of clay at this stage in order to speed up the building process and get rid of irregularities in the clay surface.

5. Where the slabs join and overlap, he works the clay together with his thumbs, pressing it around the rod to form the neck.

6. He starts to map out the features, here indicating where the eyes will be.

ROUGHING IN
THE FACE

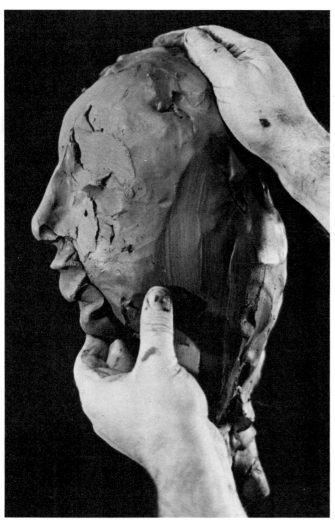

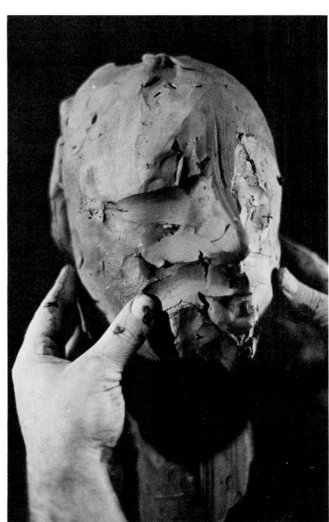

7. To quickly establish the profile, he lays a length of rolled clay down the middle of the face, from top to bottom, pushing it in with the heel of his hand to rough in the nose, lips, and chin.

8. With his thumbs, he sweeps the clay back from the midline of the face.

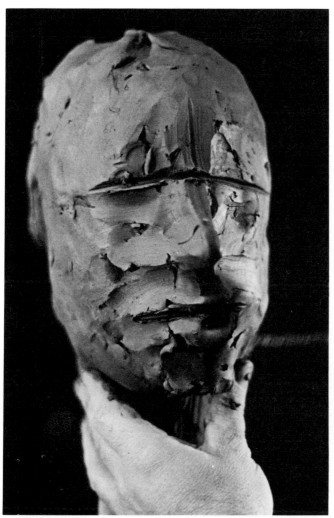 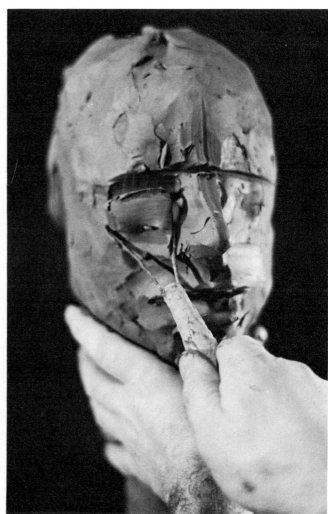

9. Now, with a wire-end tool, he draws in the line of the eyebrows and lips.

10. Then he gouges out the eye sockets with a large wire-end tool.

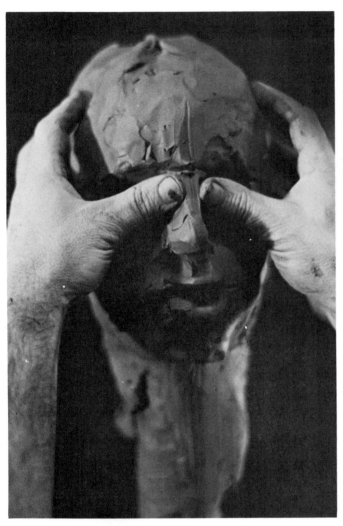 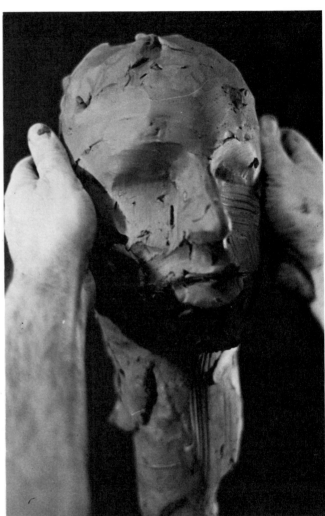

11. He presses into the sockets, sweeping his thumbs up and out from the bridge of the nose.

12. To move the modeling around to the temples and cheekbones, Lucchesi sweeps the clay back and around the facial contour with his thumbs.

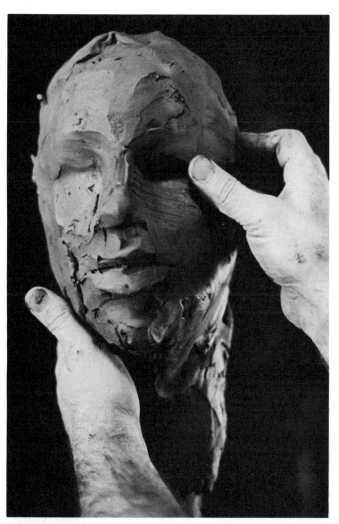

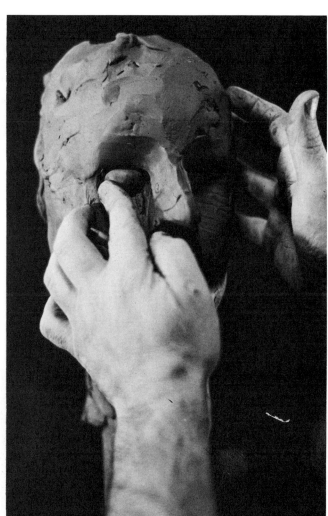

13. He depresses the eye sockets to make a cavity into which he will place the eyeball.

14. He rolls a ball of clay and places it into the socket.

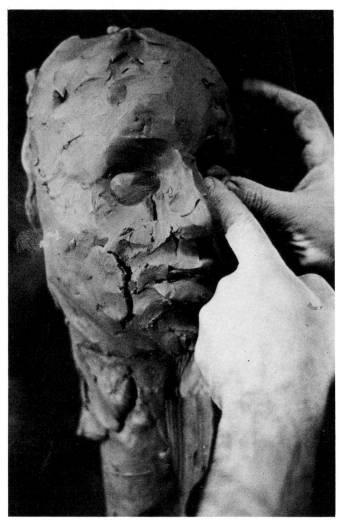 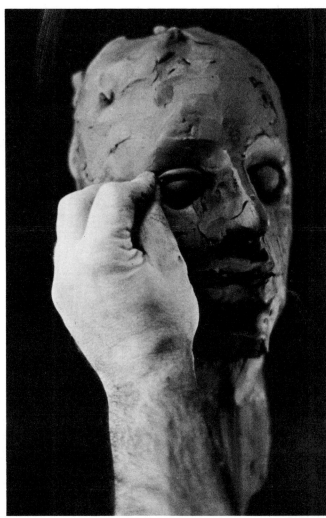

15. He gently presses the second eyeball into its socket.

16. To make the eyelid, he rolls out a small coil of clay and positions it over the eyeball (see above).

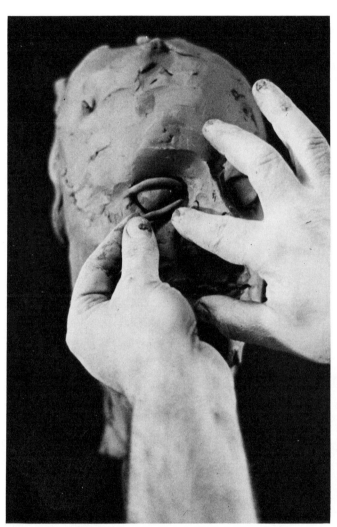 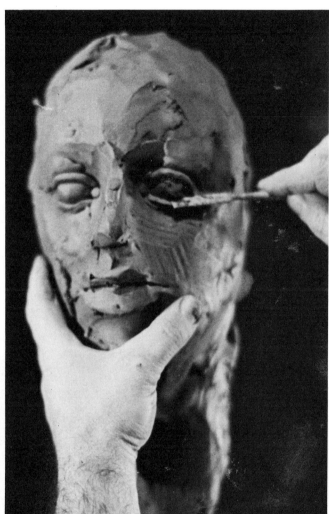

17. He rolls another coil for the lower lid and presses it into position.

18. Here Lucchesi uses a plaster tool to further define the eyelids and work the clay into the surrounding area.

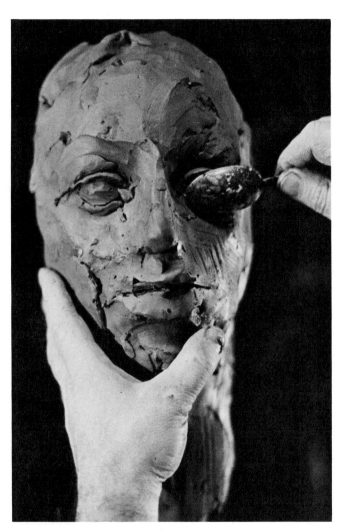

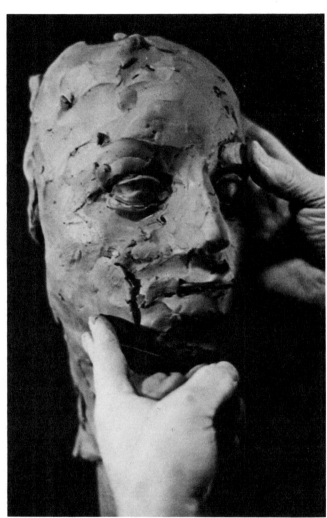

19. Whatever Lucchesi has on hand in the studio is eventually pressed into service as a modeling tool. Here he uses a spoon, which, because of its concave oval shape, is particularly well suited to shaping the eye.

20. Using a firm pressure of his thumb, Lucchesi models the upper eye area and indicates the line of the eyebrow.

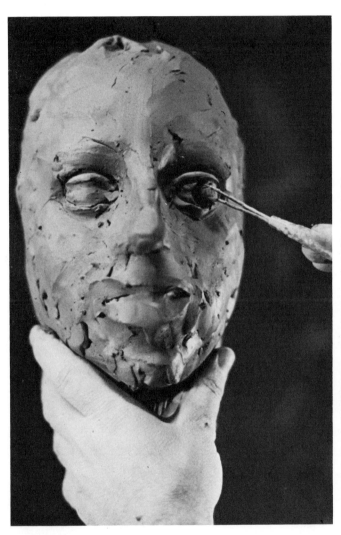

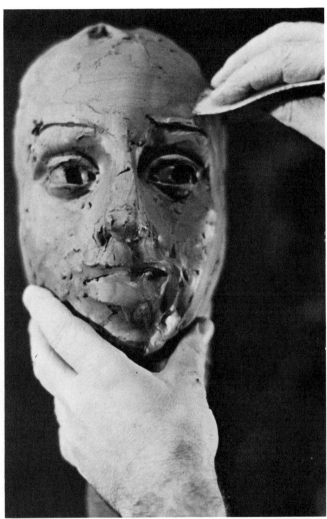

21. With an oval-shaped wire-end tool, he plucks a ball of clay out of the eyeball to make the dark part of the eye, or iris.

22. Here Lucchesi draws a flexible plastic palette, cut from the bottom of a discarded container, over the surface to blend the clay and define the planes of the face.

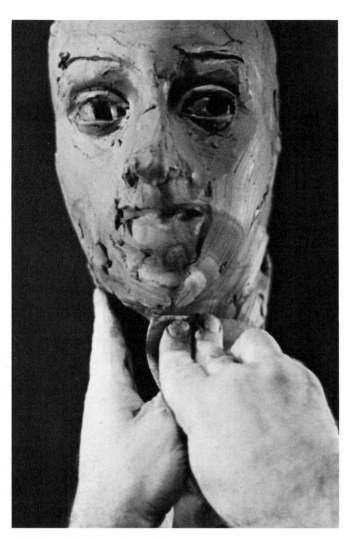

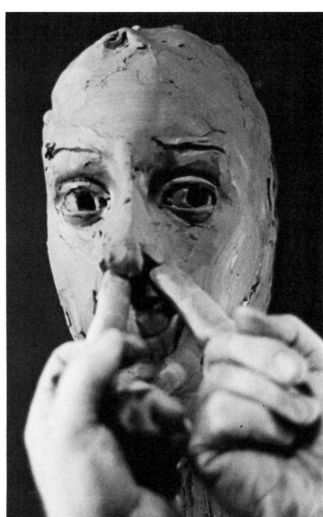

23. He pulls the palette down the cheek to the throat with a steady pressure of his fingertips, "spreading" the clay over the surface.

24. Here he uses his fingertips to press the nostril shapes out of the clay of the nose, exerting equal pressure on each side so that the nostrils will come out even.

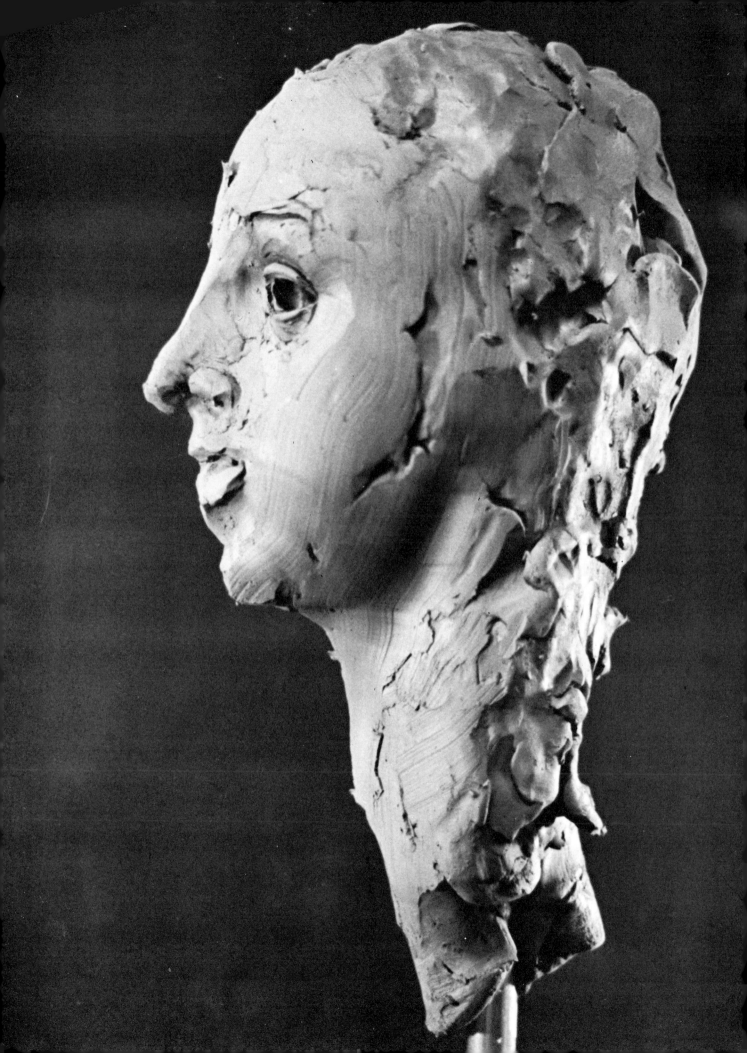

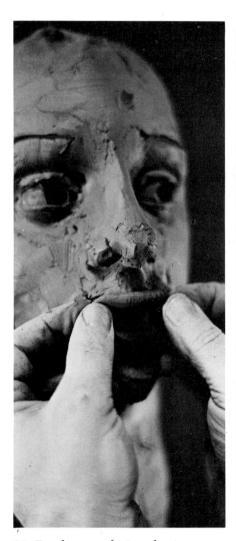

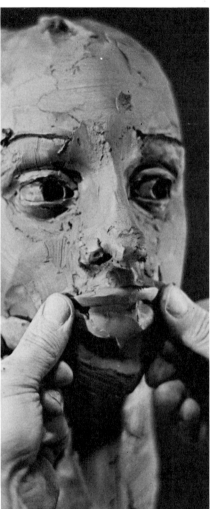

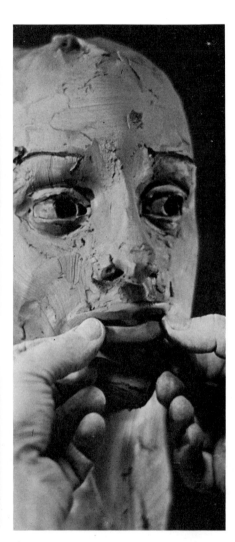

25. For the mouth, Lucchesi rolls two coils of clay, one for the upper lip and one for the lower lip. Here he presses the upper lip into position.

26. He works in the clay of the upper lip.

27. Then he places the lower lip into position.

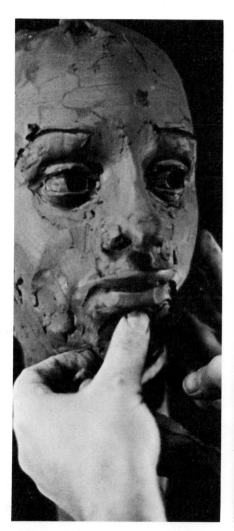 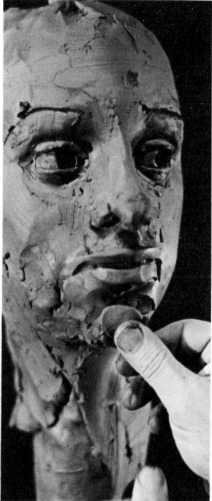 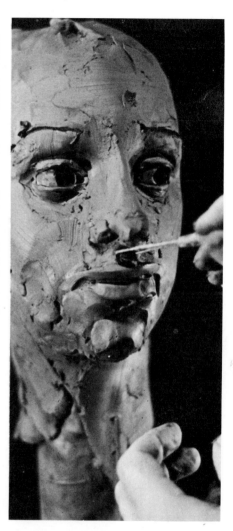

28. He presses into the clay with his thumb to form the indentation beneath the lower lip.

29. For the chin, Lucchesi pats out a small mound of clay and presses it into position, pushing into the center with his thumb to form the cleft.

30. With an oval-shaped wire-end tool he digs out the depression in the upper lip.

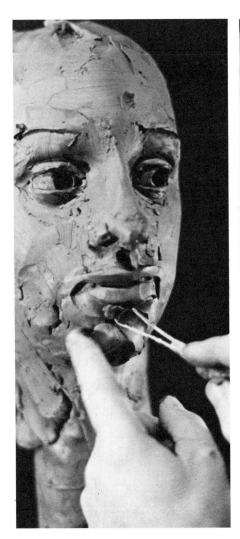 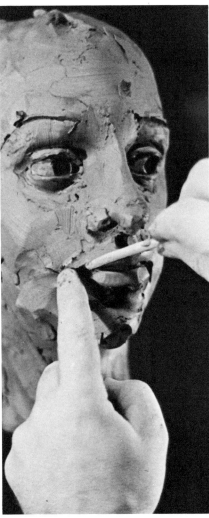 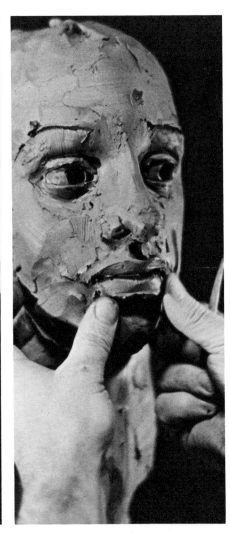

31. Here he digs out the indentation beneath the lower lip.

32. With a modeling tool, he presses indentations into each corner of the mouth.

33. Now he uses his thumbs to model the lips, here pressing his thumbnails into the clay to indicate the sharp lip line.

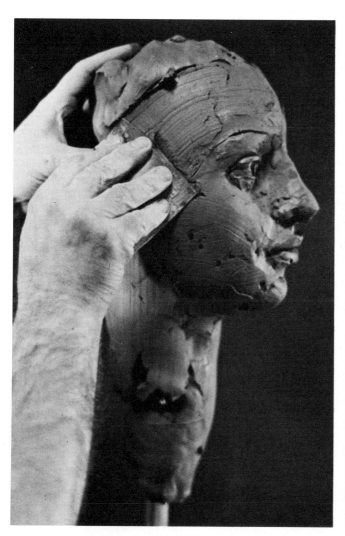

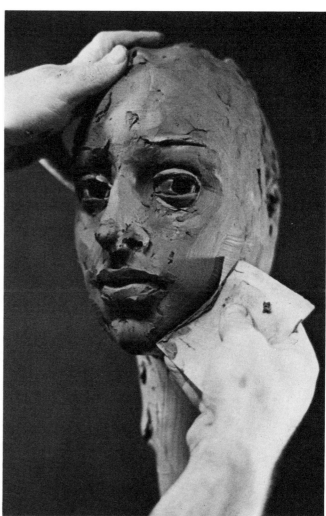

34. Again, he pulls the flexible plastic palette over the surface to "spread" the clay and define the planes.

35. He curves the palette to follow the contour of the face, here drawing it around the fullness of the cheek.

ROUGHING IN
THE EARS

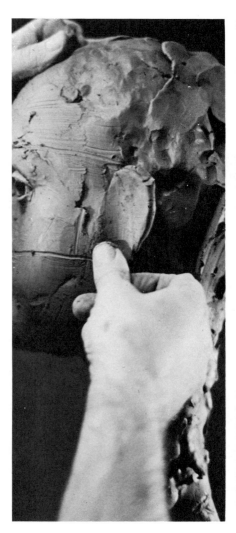 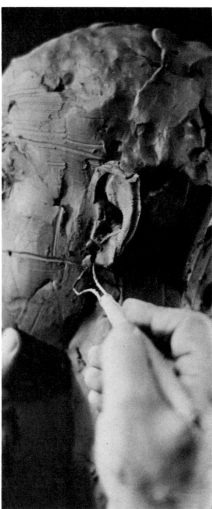 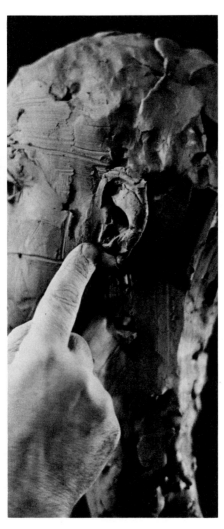

36. First Lucchesi pats out an ear-sized oval of clay, then he places it on the side of the head between the guidelines that he has drawn from the eyebrow and the end of the nose.

37. With a wire-end tool, he draws the basic S shape of the inside of the ear and carves around the fatty mound of the earlobe.

38. Here Lucchesi softens the modeling and blends the clay with his fingertip.

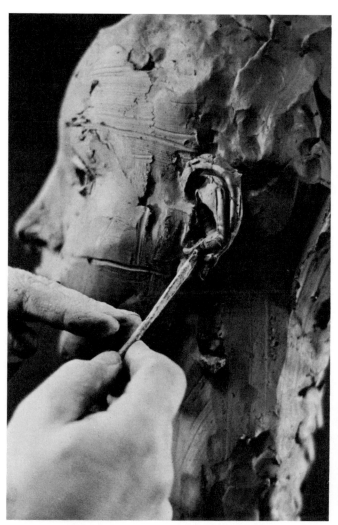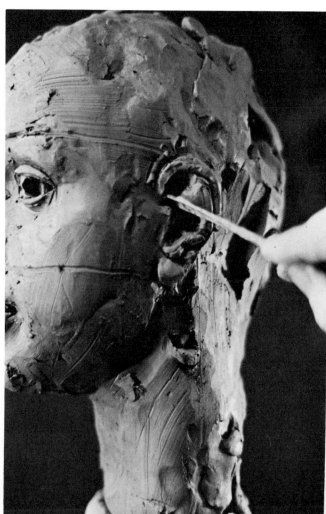

39. Now he switches to a narrow steel plaster tool to model the fine details of the ear.

40. Here he uses the plaster tool to model the delicate contours of the inside of the ear.

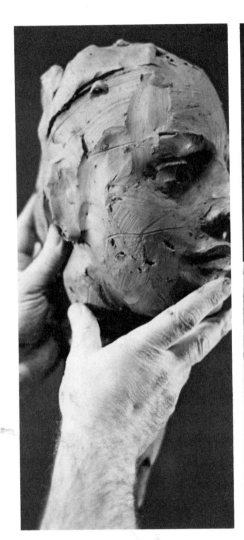 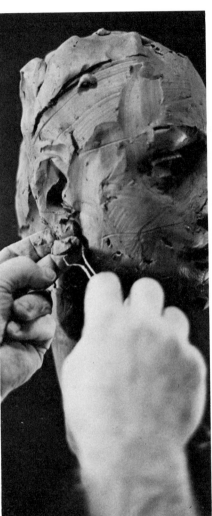 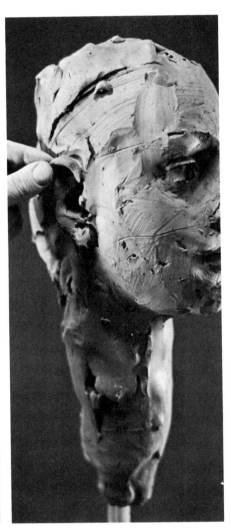

41. Lucchesi positions the second ear. Again notice the guidelines that run from the eyebrow and the end of the nose.

42. Again, he draws the S-shape of the inside of the ear with a wire-end tool and carves out the fatty mound of the earlobe.

43. He lays a small coil of clay along the top of the ear, where the edge curls over.

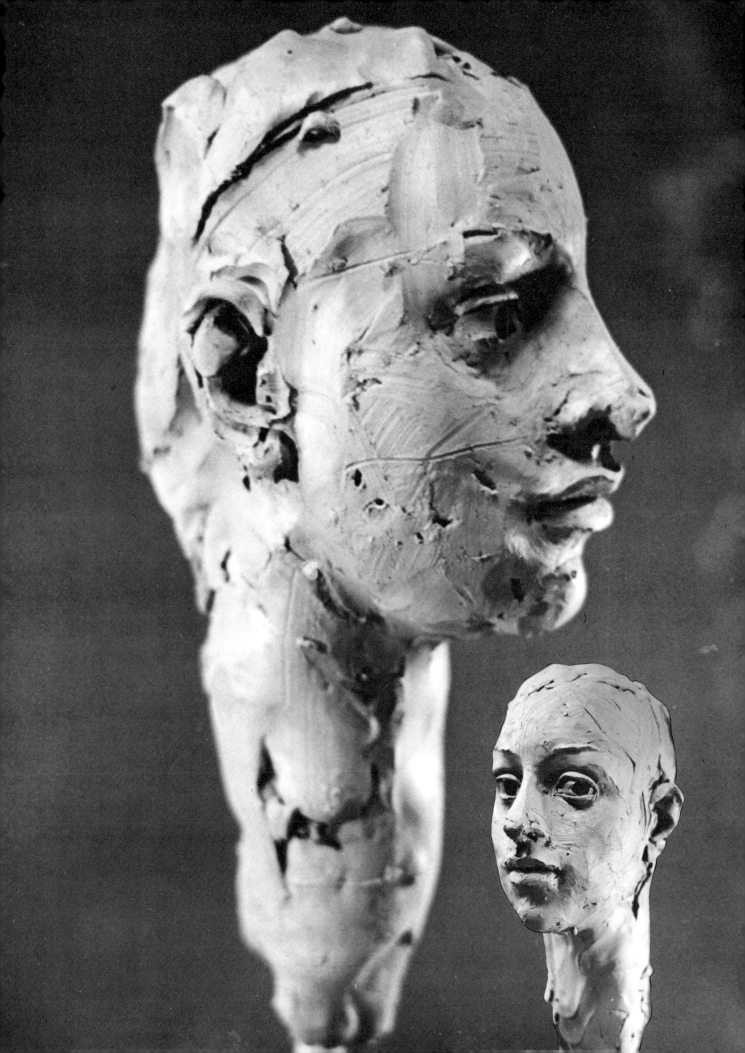

MODELING
THE FACE

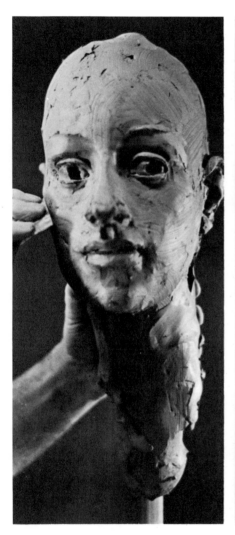 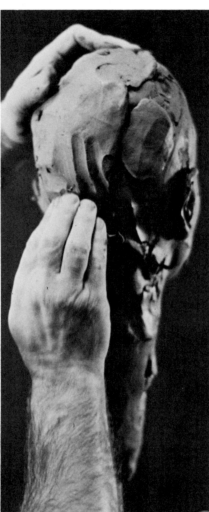 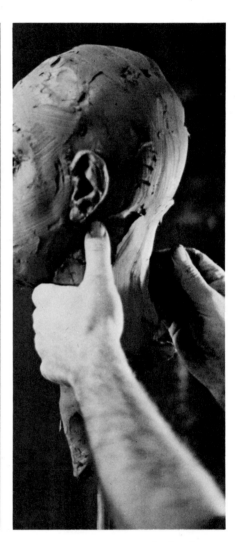

44. Now Lucchesi goes over the surface with the flexible plastic palette to pull the clay together and give the piece a uniform overall texture.

45. He adds clay at the back to complete the head mass, blending it in with a strong pulling motion of his fingertips.

46. He also adds clay to the back of the neck, sweeping the clay up into the head mass.

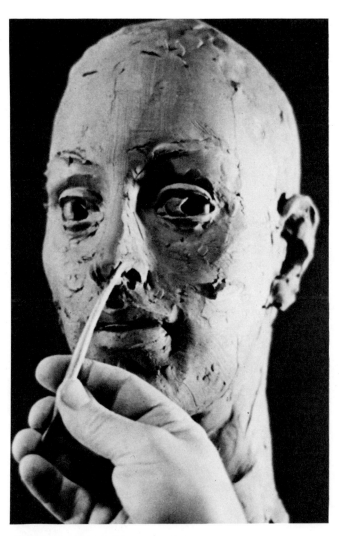

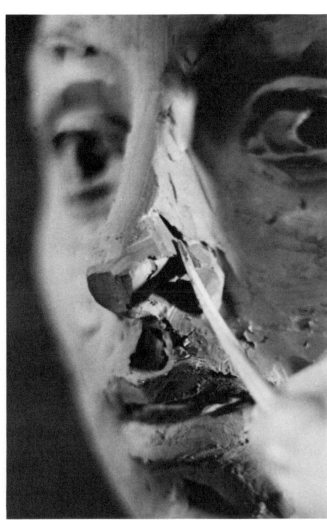

47. Here Lucchesi uses a modeling tool to open up and define the nostrils.

48. He flattens the end of the nose to indicate the cleft in the cartilage and rounds out the nostrils.

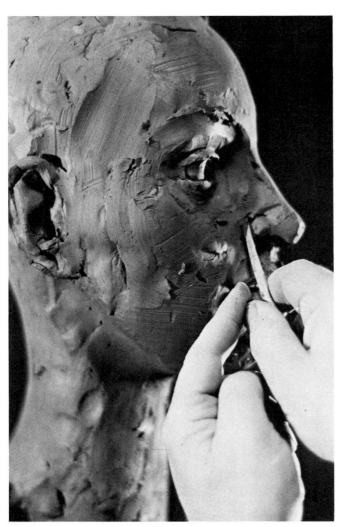 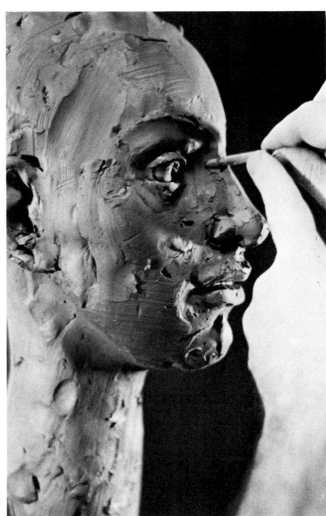

49. Here Lucchesi emphasizes the indentation between cheek and nostril with the modeling tool.

50. Drawing the modeling tool over the clay with a downward motion, Lucchesi contours the side of the nose.

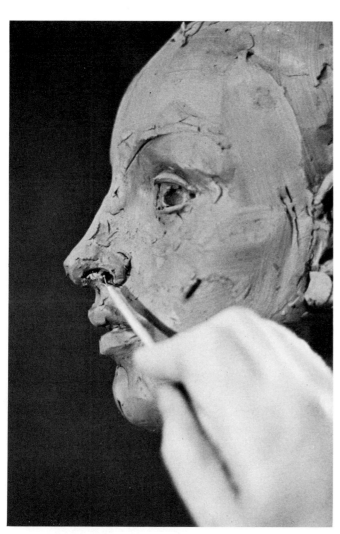

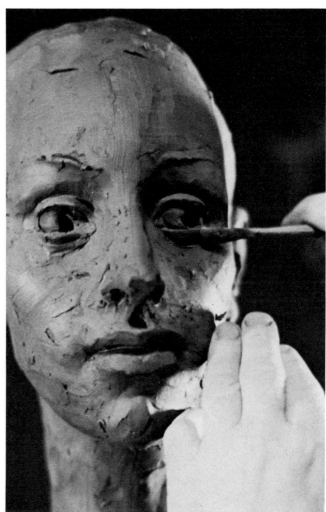

51. Here he digs more clay from the nostril with a wire-end tool.

52. He draws a plaster tool around the contour of the lower lid to give it fullness and definition.

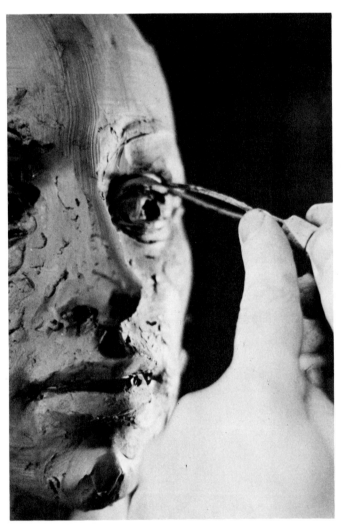

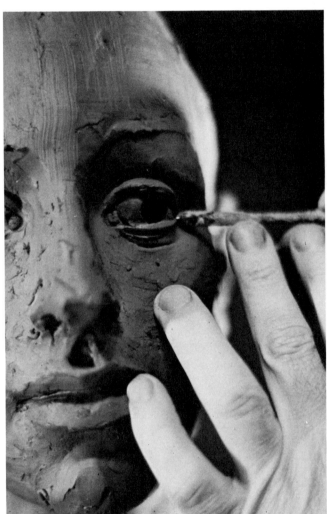

53. Here Lucchesi draws a plaster tool around the upper lid, accentuating the crease between the eyelid and the bony prominence of the eye socket.

54. To sharpen the modeling, he draws a plaster tool along the lower lid, giving it a light-catching edge.

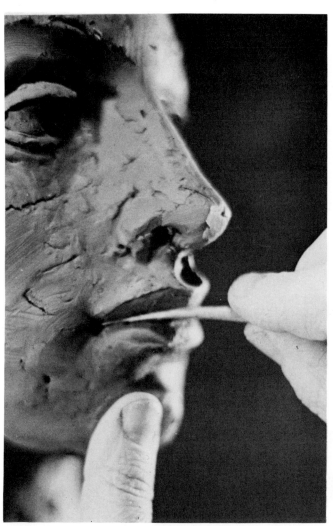

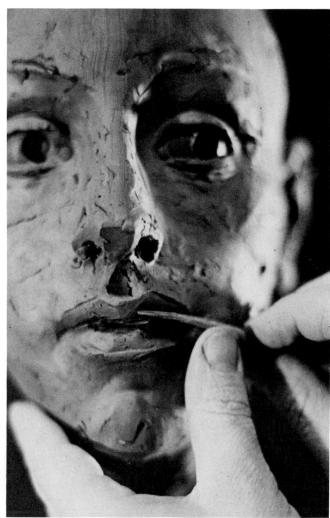

55. Now, with a modeling tool, he opens up the lips and gives them a full, rounded contour.

56. He accentuates the protrusion in the middle of the upper lip by pressing the tool into either side of it.

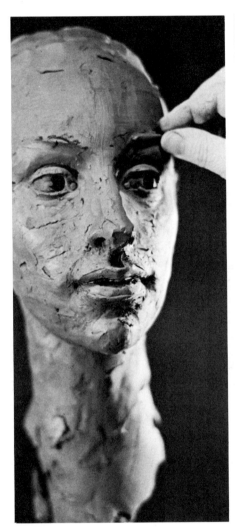 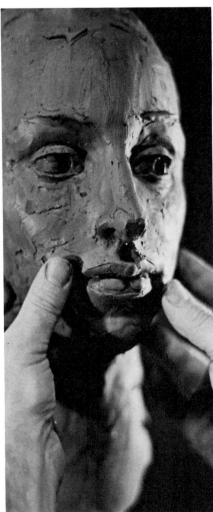 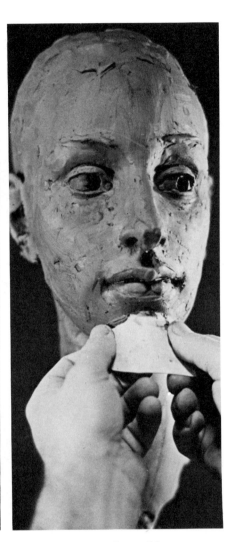

57. He rolls a small coil of clay for the eyebrow and presses it on, "tweaking" it into position.

58. Here he uses his thumbs to model the rounded muscle mass on either side of the mouth.

59. He presses a piece of heavy paper against the clay of the chin to define the roundness of its contour.

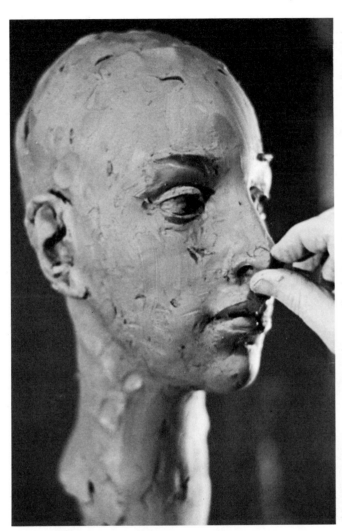

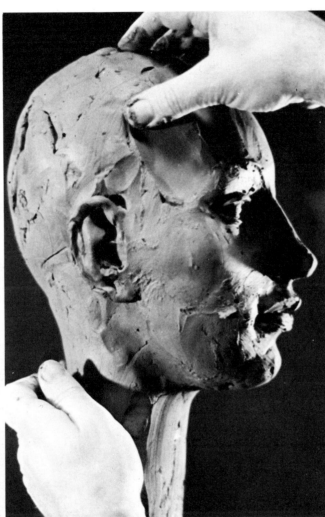

60. He tilts the end of the nose with a pinch of his fingers.

61. Here Lucchesi depresses the temple with a sweep of his thumb.

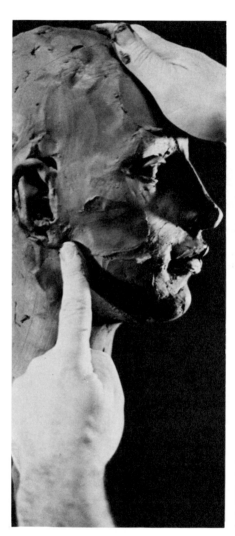 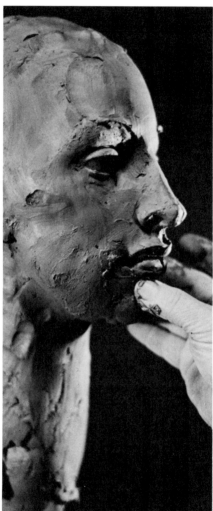 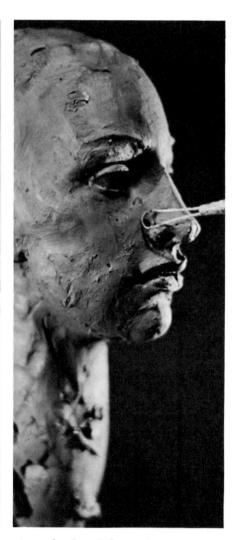

62. To define the jawline, Lucchesi locates the back of the jaw, just under the earlobe.

63. Picking up very wet clay, Lucchesi moves it over the surface to fill in the irregularities.

64. He further defines the juncture between cheek and nose with a wire-end tool.

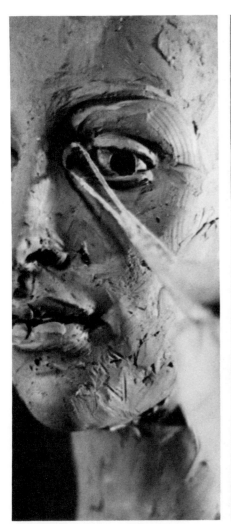 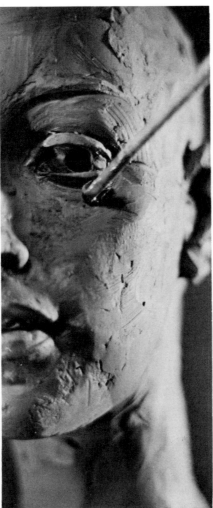 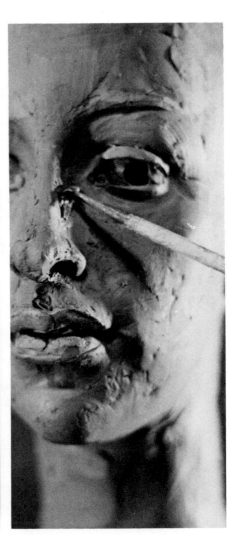

65. Bringing the tool up, he models the inside corner of the eye and the slope of the cheek as it rises to meet the side of the nose.

66. Now he draws a wet watercolor brush over the eye, digging into the clay with the heel of the brush.

67. He brings the brush down to the side of the nose.

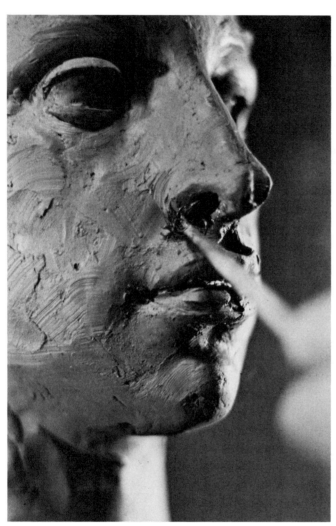

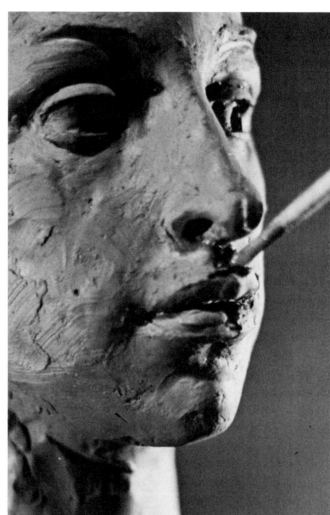

68. Here he swirls the wet brush around the edge of, and inside, the nostrils.

69. Then he works it into the depression of the upper lip.

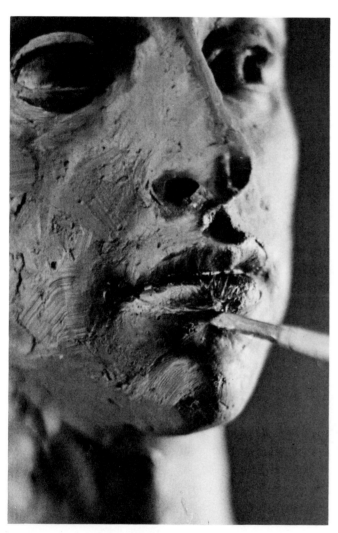 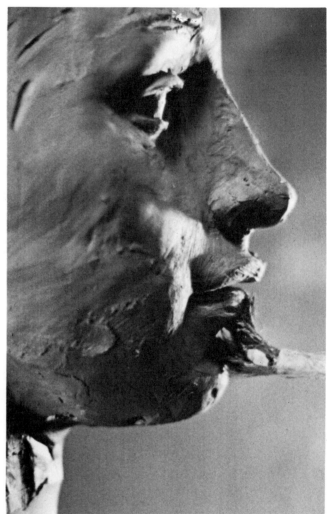

70. He moves the hairs of the brush up and down over the lips, following the direction of the muscle, which radiates outward from the center.

71. Here is a side view of this up-and-down movement of the brush over the lips.

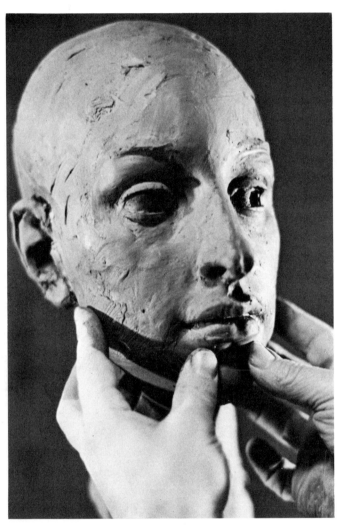

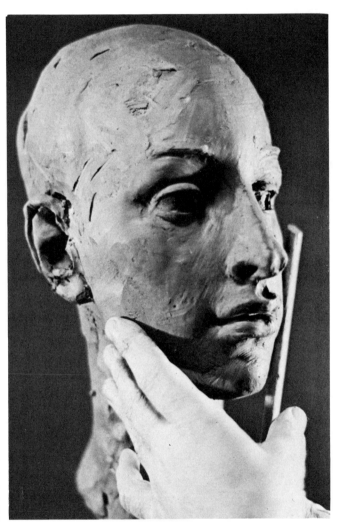

72. To make sure that both sides of the face are developing evenly, Lucchesi gently pushes and presses, gauging the volumes with both eye and fingertips.

73. To even out irregularities and modeling marks in the surface, Lucchesi rolls a wooden dowel in a rapid back-and-forth movement, turning it this way and that, over the forms of the face.

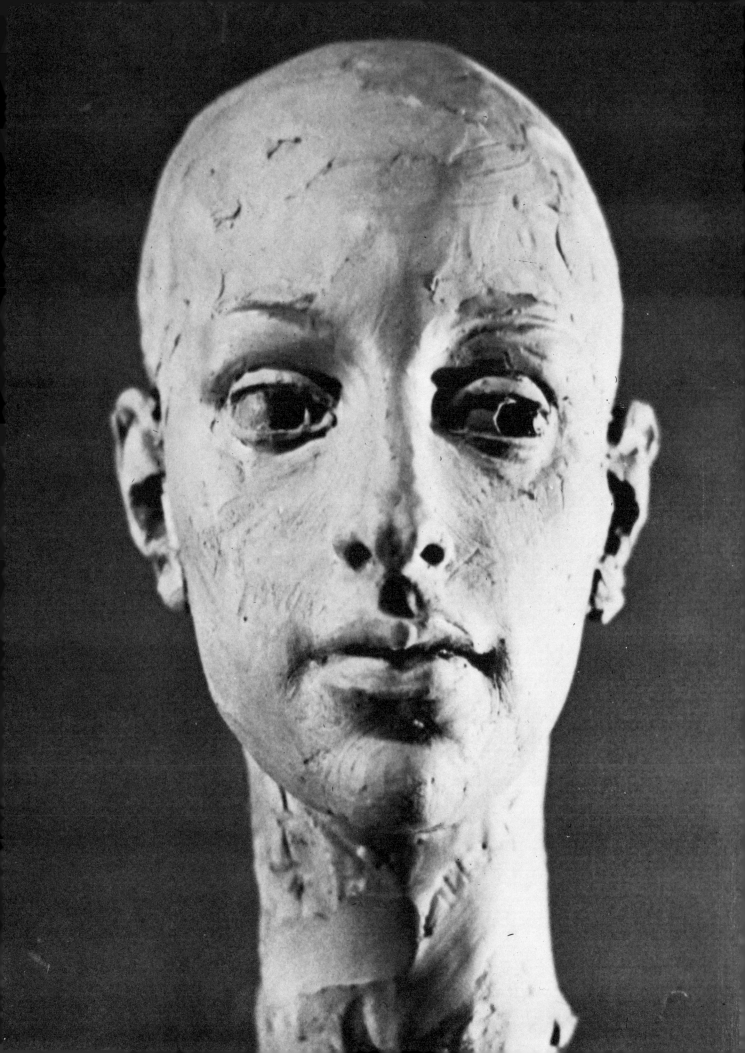

ADDING THE
HAIR MASS

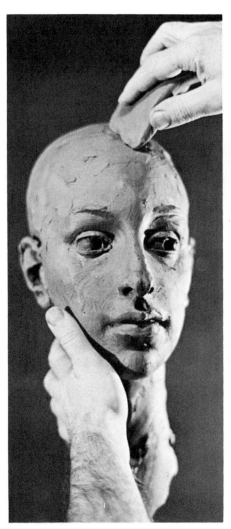 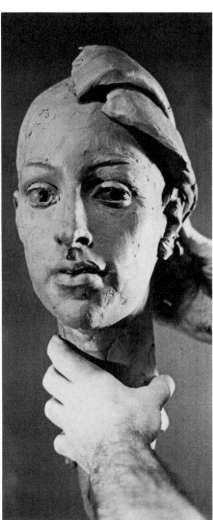 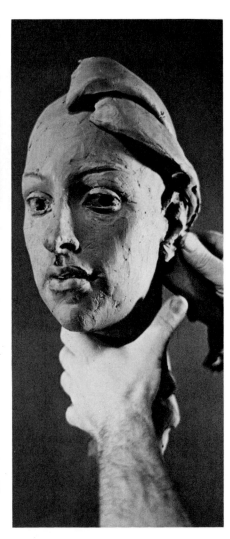

74. Now that the head is fully formed, hair may be added. Lucchesi makes his hair out of slabs and coils rather than laying it on all at once. Each mass of hair grows vigorously out of the scalp rather than lying flat and limp.

75. He adds a second slab of clay, curving it behind the ear.

76. He presses a third slab into the base of the skull and curves it into shape.

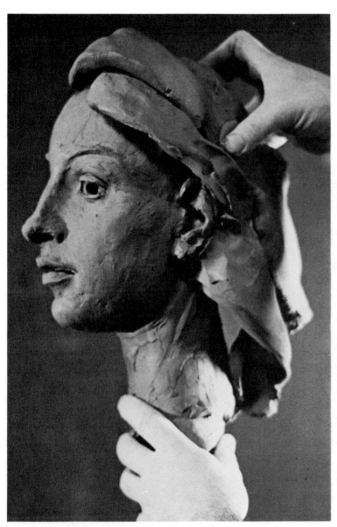

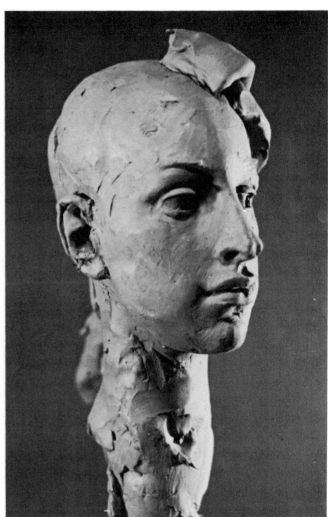

77. He adds more clay at the back, smearing it in with his thumb.

78. Now he moves to the other side of the head.

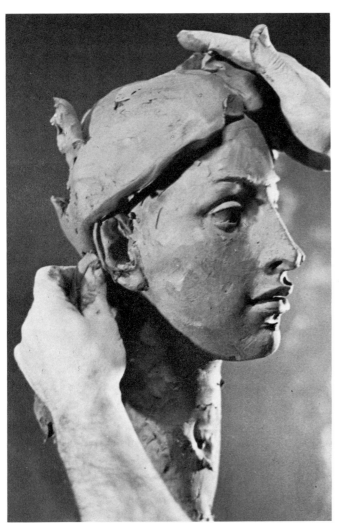

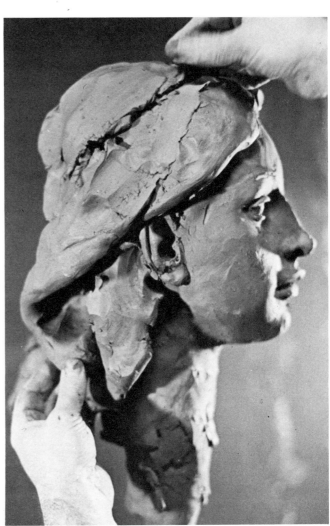

79. Lucchesi lays down one slab of clay, then another, working them into the skull with his thumb.

80. He drapes and curves the hair as he goes along.

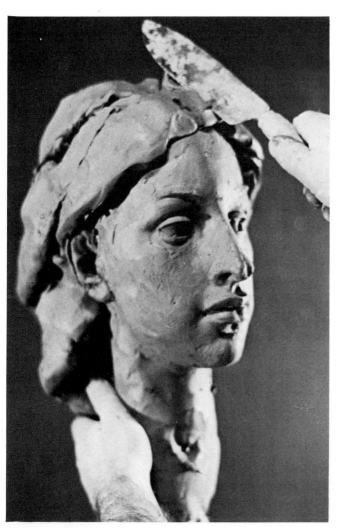

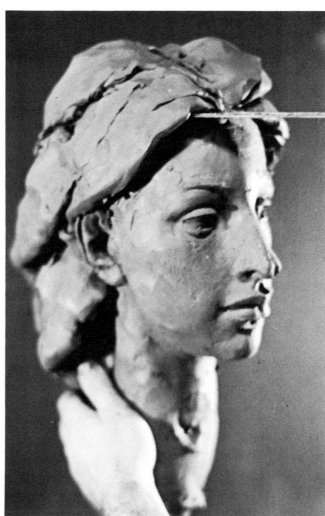

81. Using a large plaster knife, he whacks the clay down and defines the part in the center.

82. He lifts and shapes the hair with the tip of the knife.

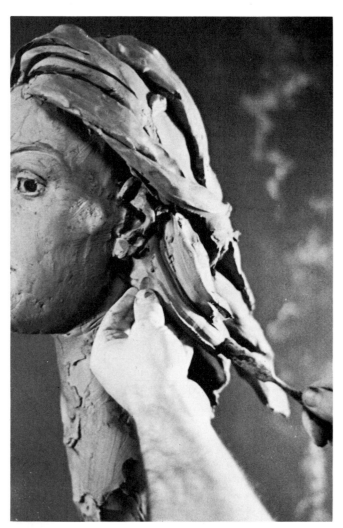

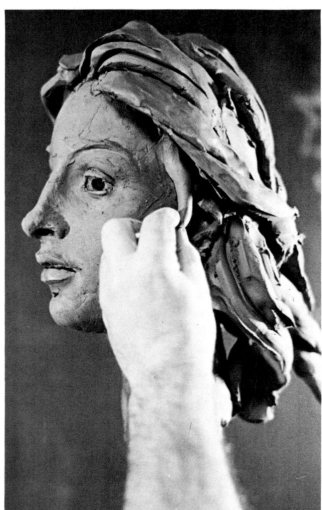

83. Now he runs a plaster tool over the clay to break the broad slabs up into strands of hair.

84. He rolls coils of clay to make curls and tendrils (see above).

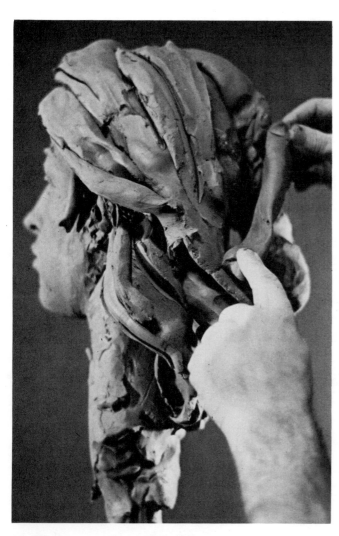 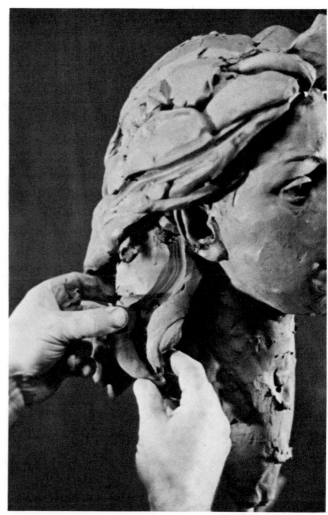

85. He also uses clay coils to fill in the gaps between the larger slabs.

86. As he builds up the hair mass, Lucchesi "arranges" the hair, guiding the overall movement and the way it falls.

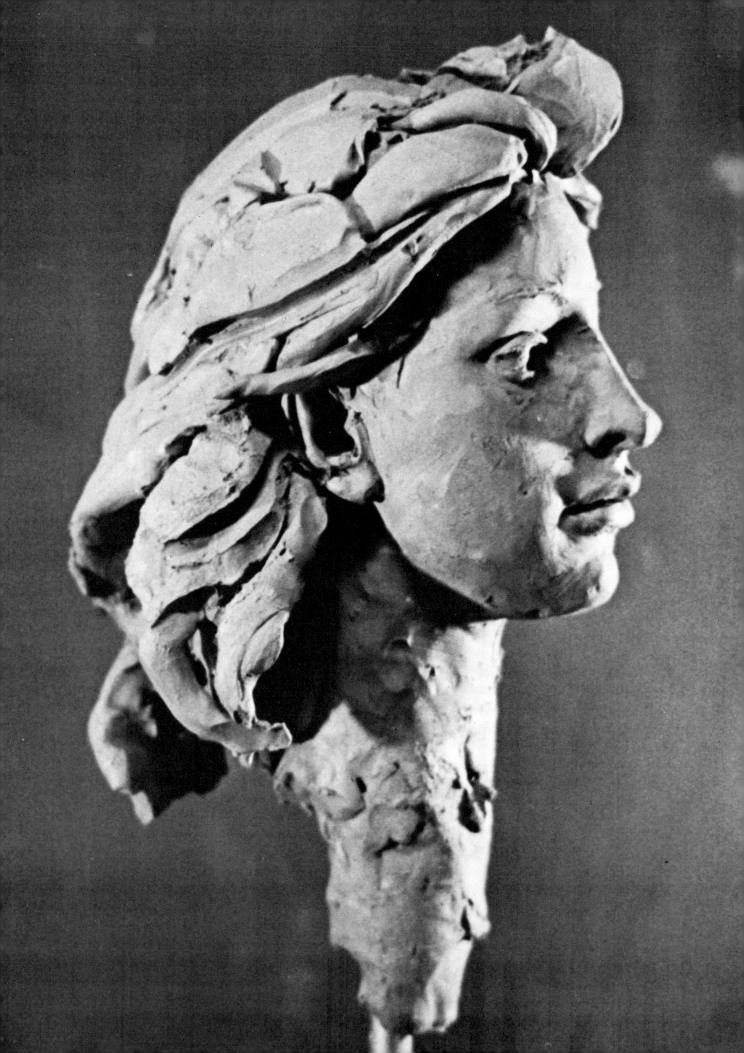

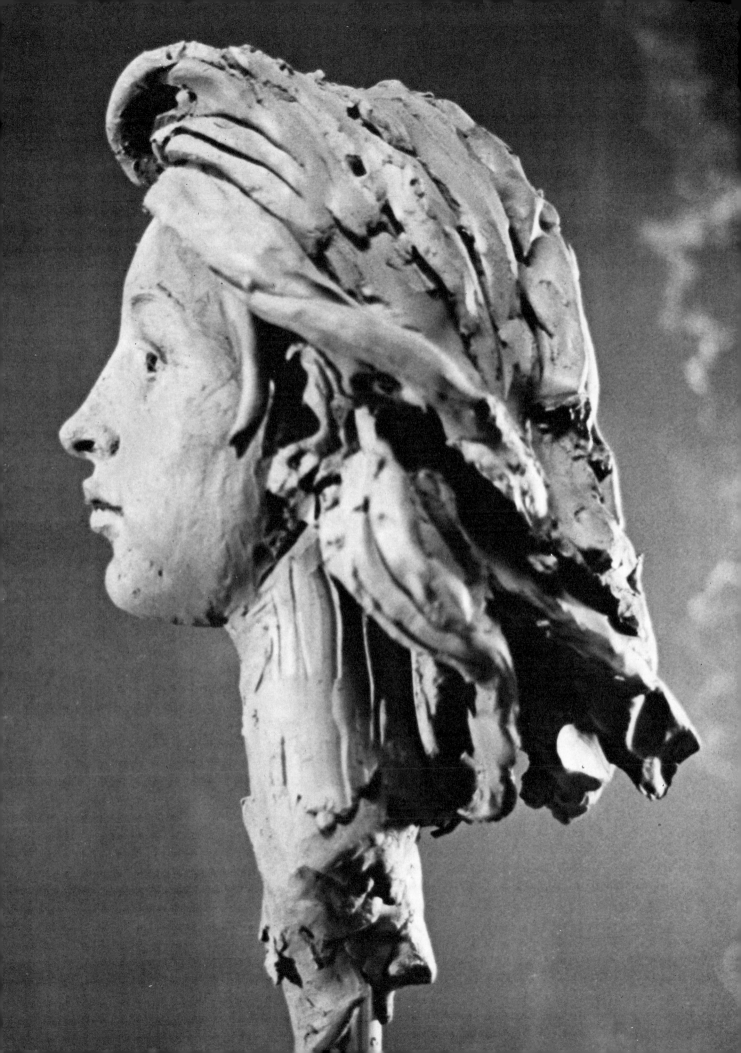

NECK AND
SHOULDERS

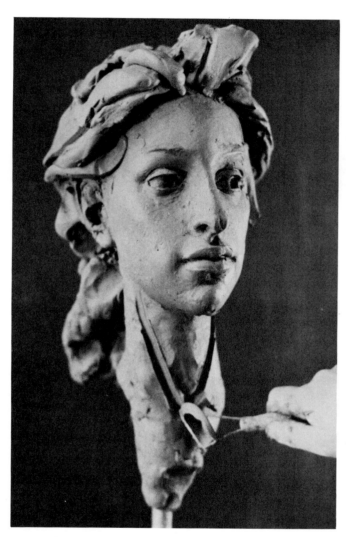

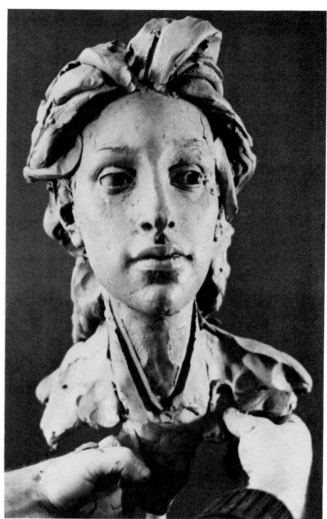

87. With a wire-end tool, Lucchesi draws in the strong V of the sternomastoid.

88. He starts to build up a hollow shoulder structure by squeezing on chunks of clay, working outward from the neck.

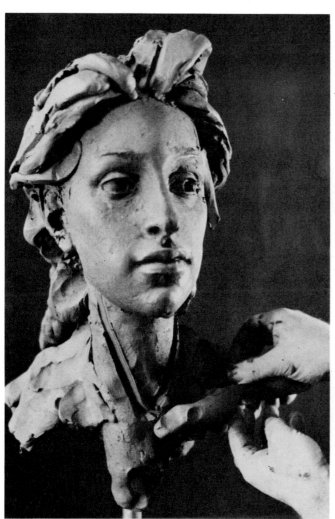

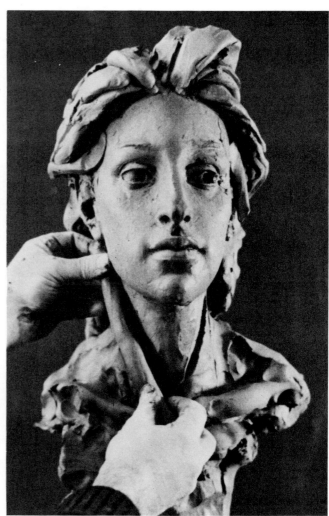

89. He forms the collarbones by rolling two large coils of clay and pressing them into position.

90. He forms the sternomastoid muscles in the same way, positioning them on top of the drawn guidelines.

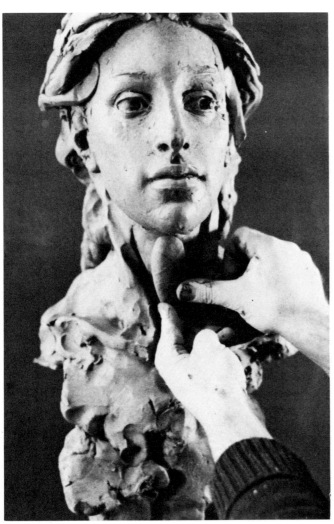 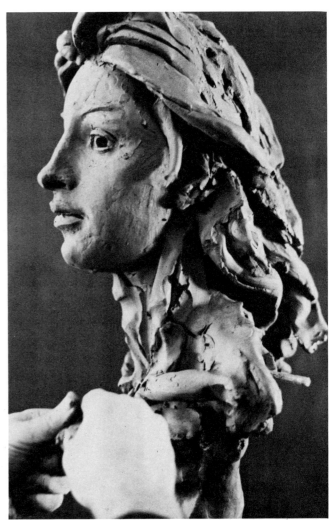

91. He places another coil of clay on the neck to form the rounded protrusion of the throat.

92. He presses this coil in to show the two separate forms made by the larynx, or Adam's apple, at the top and the thyroid at the bottom.

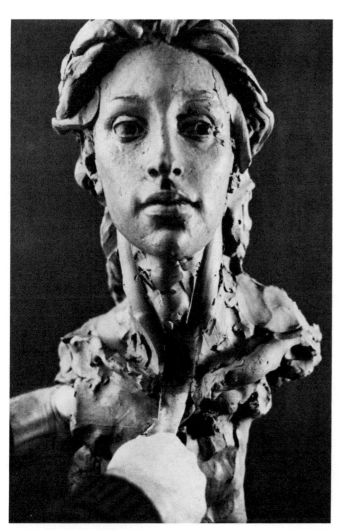

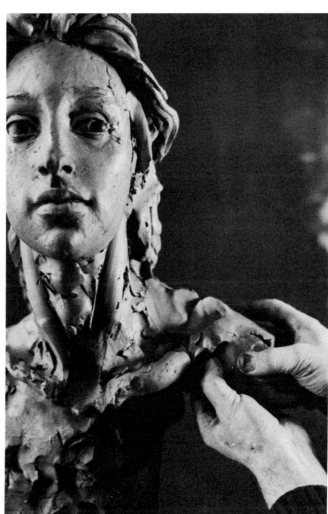

93. With a curved plaster tool, Lucchesi depresses the hollow of the neck between the ends of the collarbones.

94. He continues to build outward, adding more clay to the shoulders.

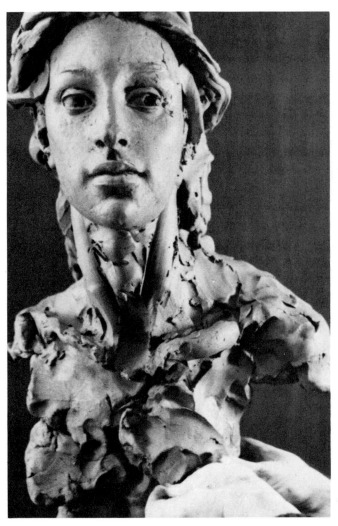

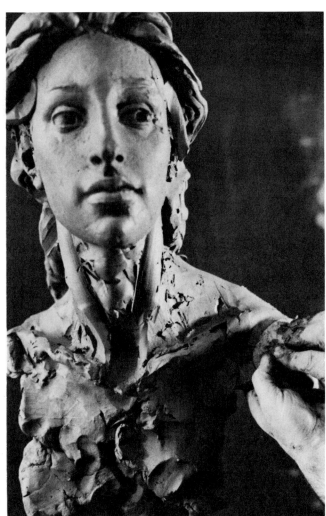

95. Now he builds downward to the bust.

96. He blends the clay of the shoulder with a flexible steel palette held curved to follow the contour of the forms.

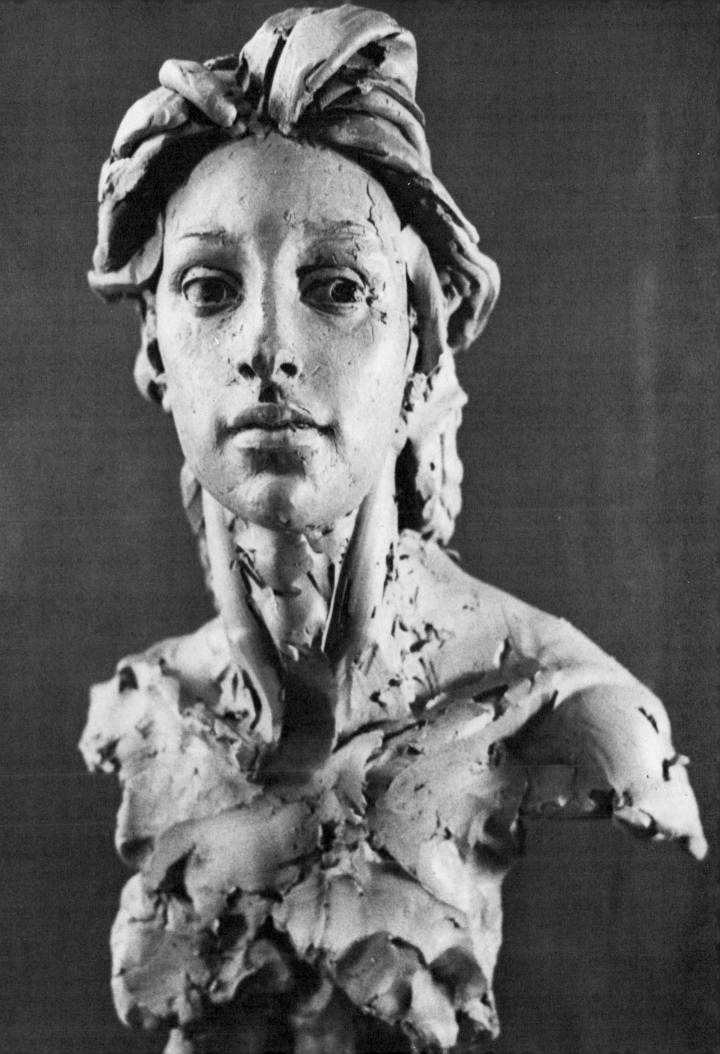

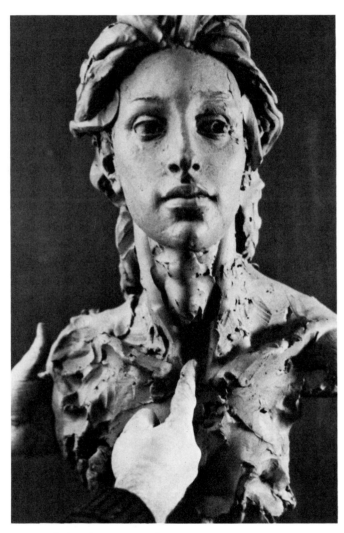

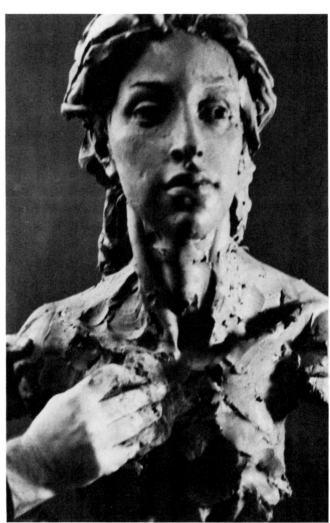

97. With his finger, Lucchesi models the sharp definition between the collarbones.

98. He pulls a flexible steel palette over the surface to model and blend the clay.

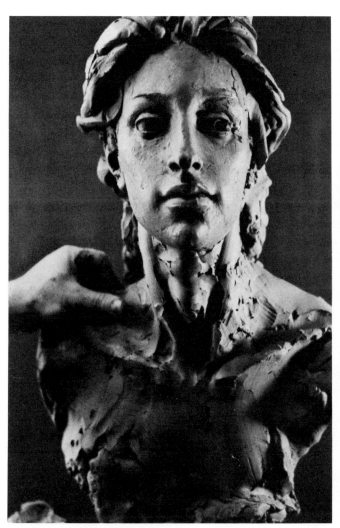

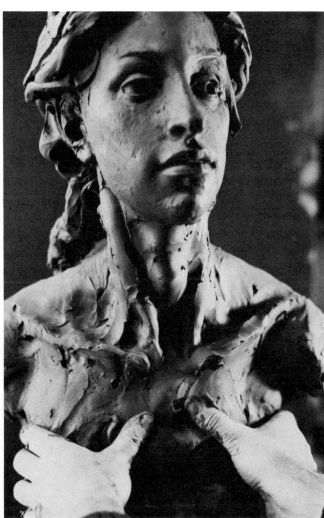

99. With gentle sweeping strokes of his thumb, Lucchesi blends and unifies the surface.

100. Moving down to the bust, he uses the full strength of his hands to pull the clay together.

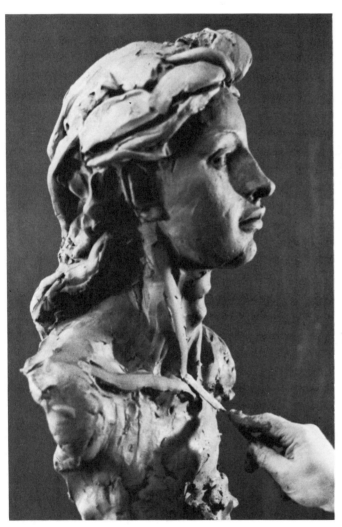

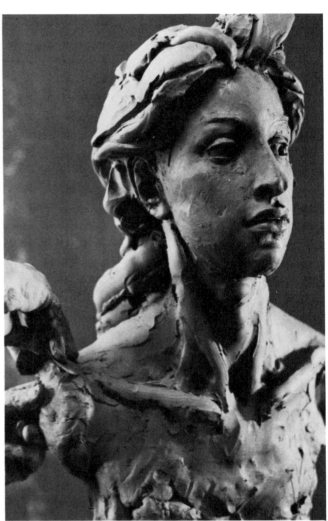

101. He draws a flat plaster tool along the collarbones and sharpens the ends at the hollow of the throat.

102. Again using a flexible steel palette, he models and rounds off the shoulders.

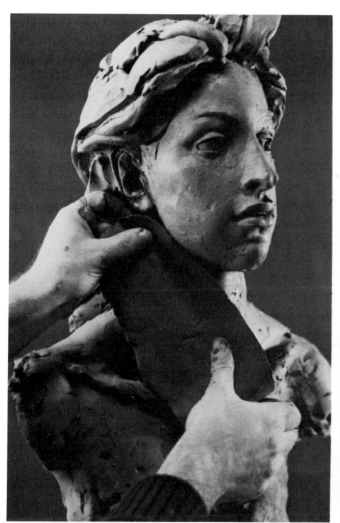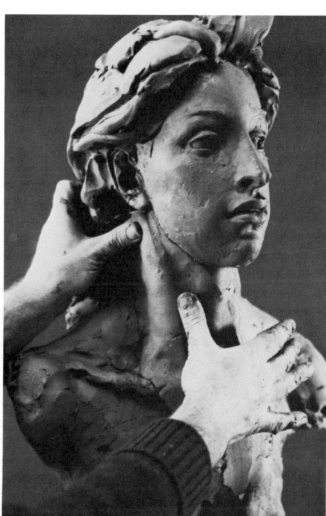

103. Here Lucchesi starts to lay the "skin" on top of the underlying structure he has built up. The clay is flattened by repeatedly throwing a ball of clay obliquely against a tabletop on the floor (see above).

104. He gently presses the layer of clay over the sternomastoid and throat.

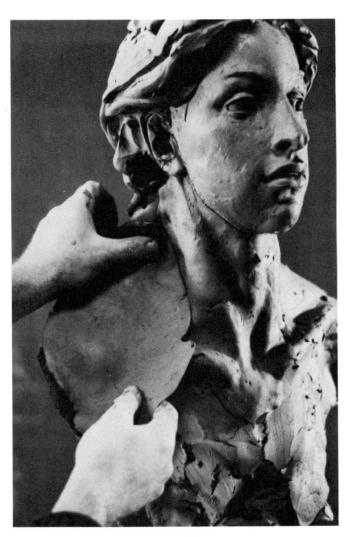

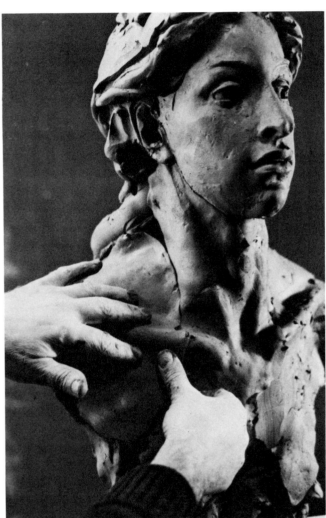

105. He drapes another layer of
clay over the shoulder.

106. Then he presses it down
around the collarbone.

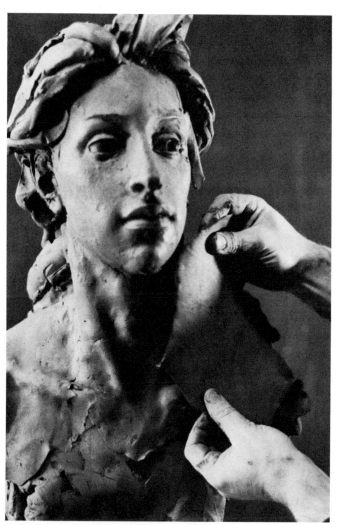

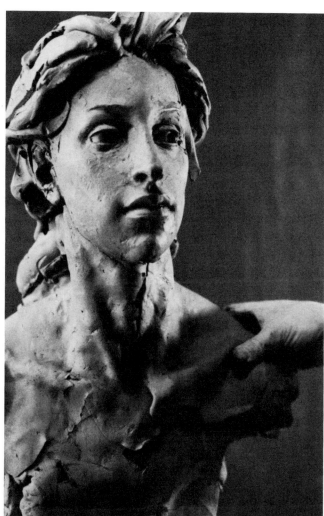

107. He covers the other shoulder.

108. And presses the clay into the underlying forms.

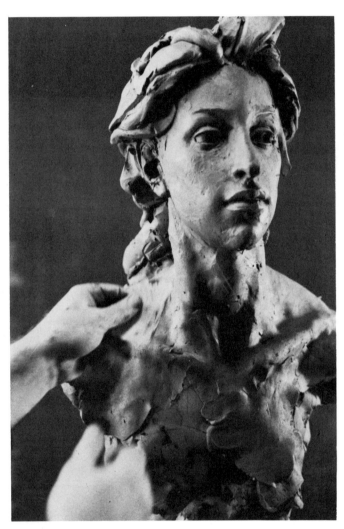

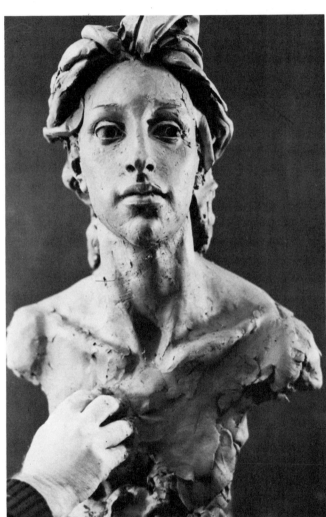

109. Now Lucchesi blends the clay together and works small dabs of wet clay into the surface with sweeping motions of his thumb to even out any irregularities.

110. Here he uses a flexible steel palette to "spread" clay over the surface.

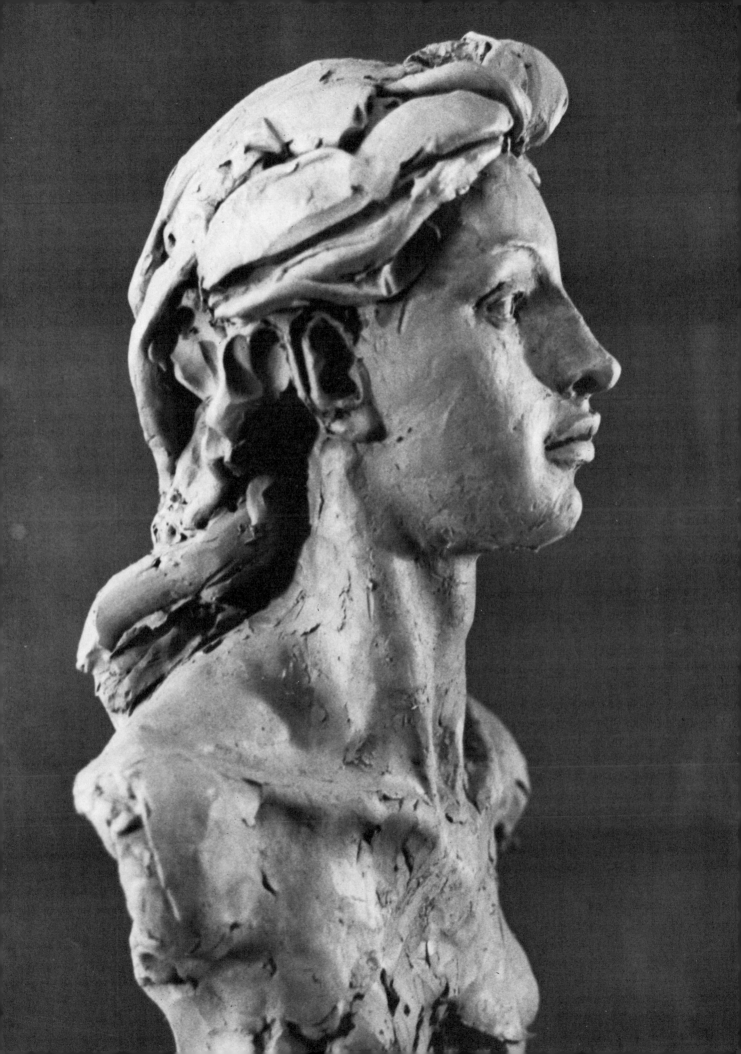

REFINING
THE EYES

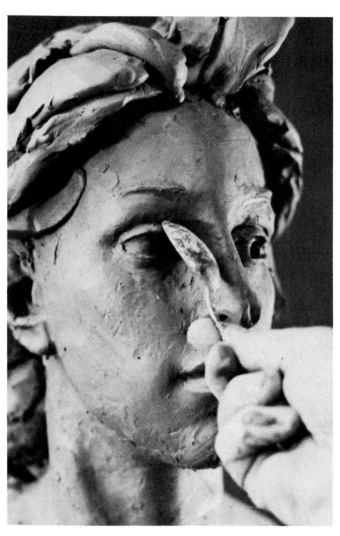

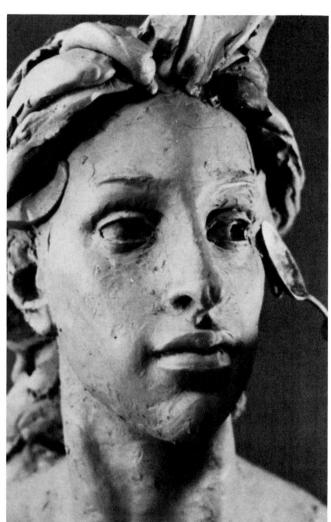

111. Here Lucchesi makes use of the spoon again to dig into and sharpen the crease of the eyelid.

112. With the back of the spoon he depresses the area above the cheekbone.

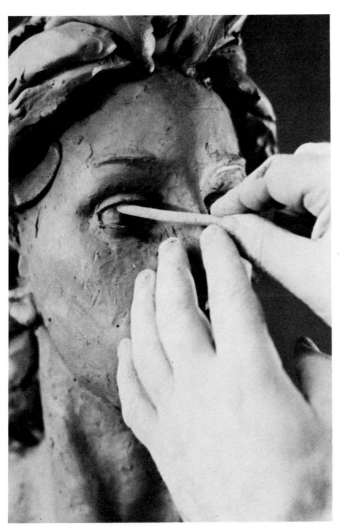

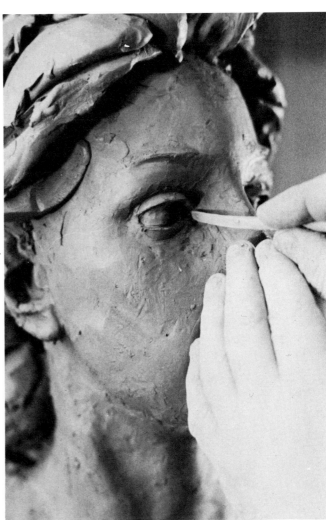

113. He uses a modeling tool to deepen the curve of the eyeball as it disappears underneath the lid.

114. Then he depresses the inside corner of the eye.

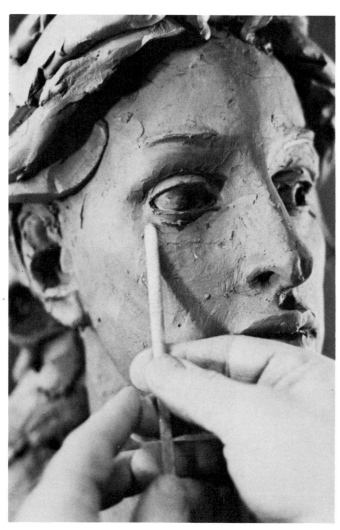

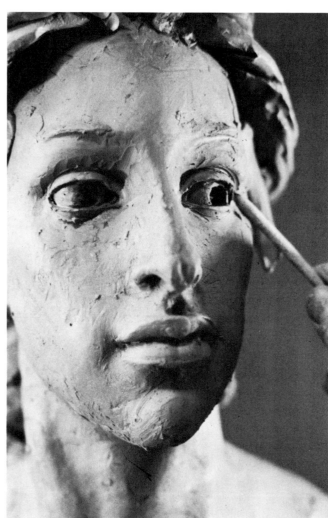

115. He moves around to work over the lower lid.

116. He draws the tool around the upper lid to sharpen the crease.

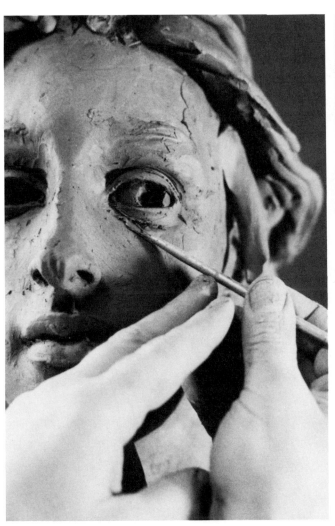

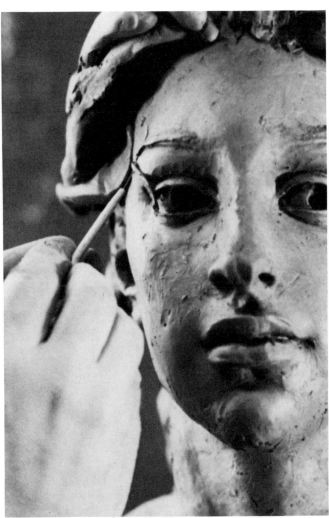

117. Now he defines the fatty area below the lower lid.

118. Here he uses a wire-end tool to carve away clay from below the eyebrows, giving them a sharper definition.

REFINING THE
FACIAL SURFACE

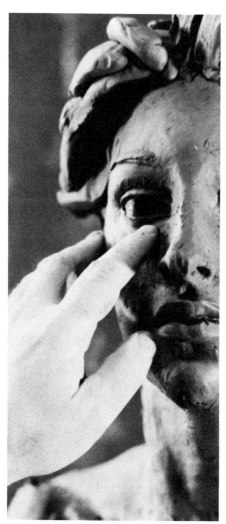 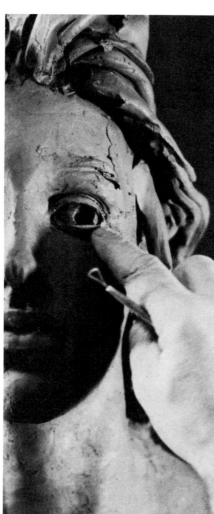 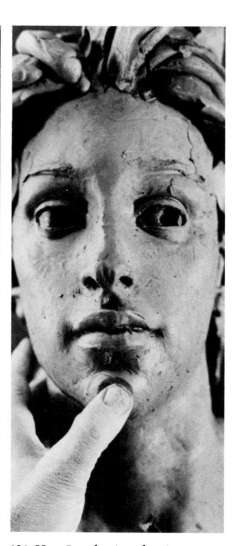

119. He blends the clay of the lower lid and cheek with his fingertip.

120. He does the same on the other side.

121. Here Lucchesi pushes in the cleft of the chin.

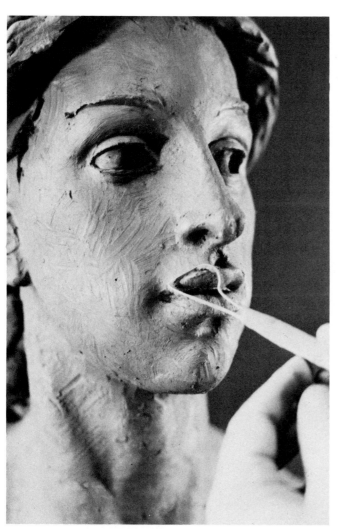

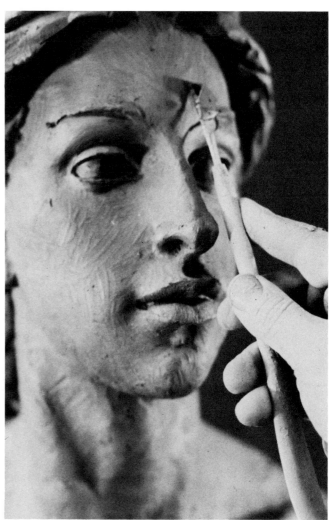

122. With a wire-end tool, he sharpens the edge of the lips.

123. Then he uses the tool to go over the surface of the face, lightly carving a uniform surface into the clay.

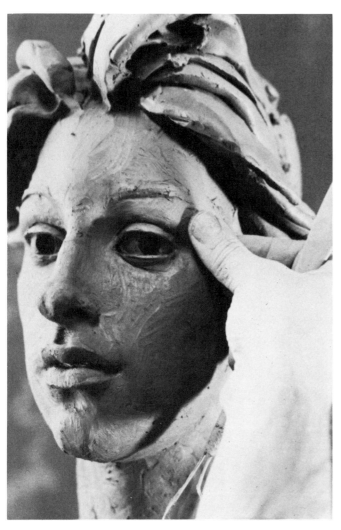

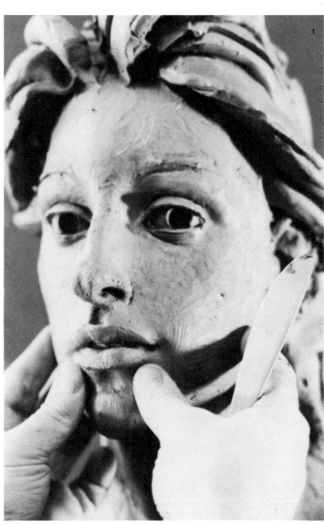

124. With his thumb, Lucchesi blends and smooths the clay around the eye.

125. Using both thumbs to press the clay evenly, he goes over the contours of the lower lip.

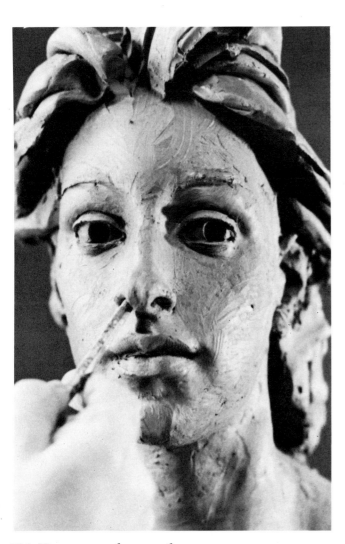

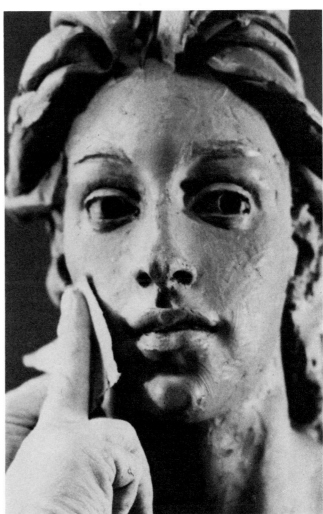

126. He opens up the nostrils with a modeling tool.

127. Here he presses a piece of cardboard against the clay to texture and smooth the surface.

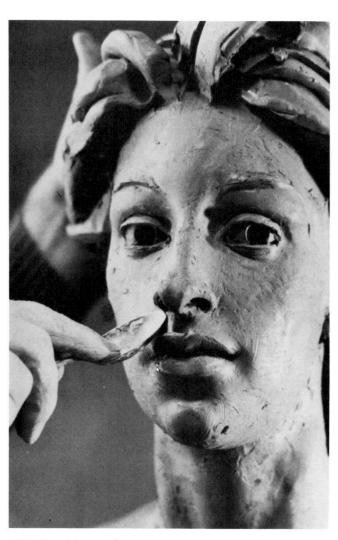

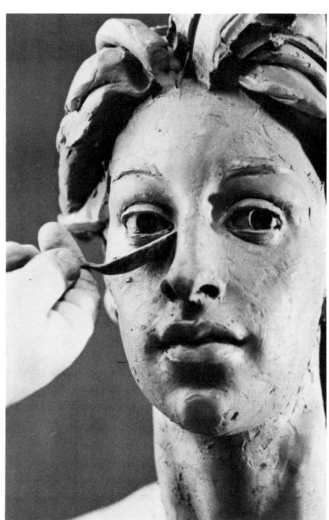

128. He picks up the spoon again, here to depress the curve of the upper lip.

129. And here to define the crease in the lower lid.

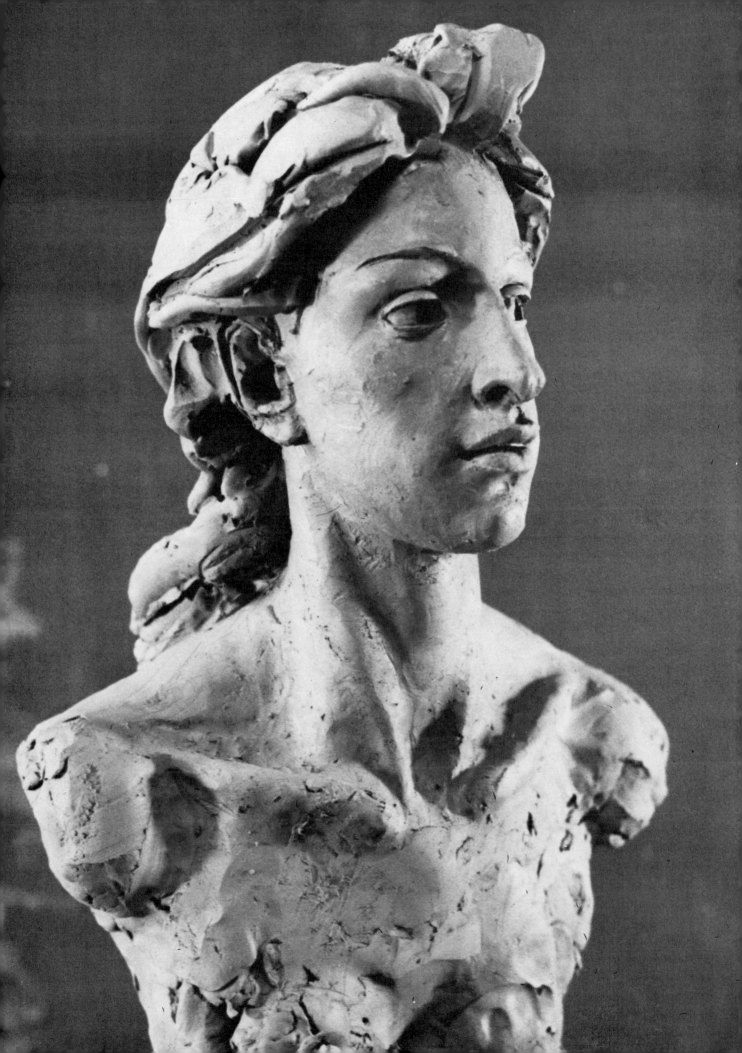

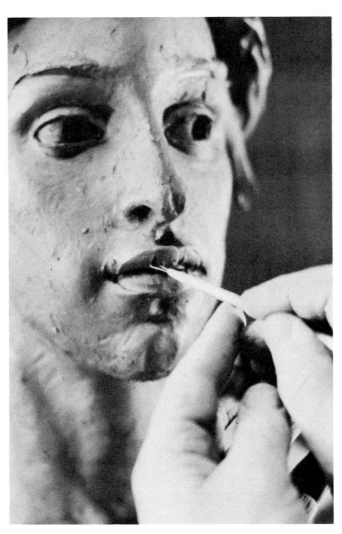

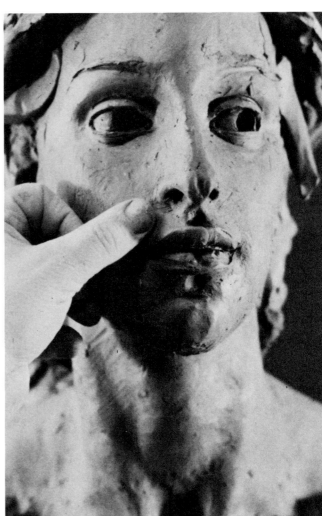

130. With a small wire-end tool, Lucchesi incises the major creases in the lips.

131. He smooths over the clay of the upper lip area with his thumb.

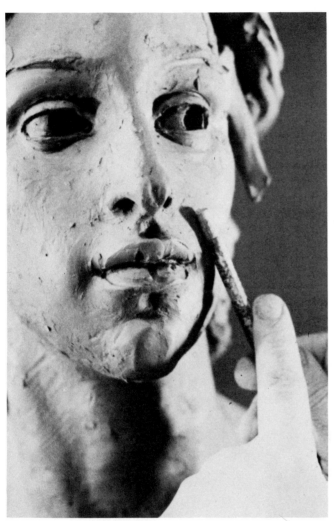

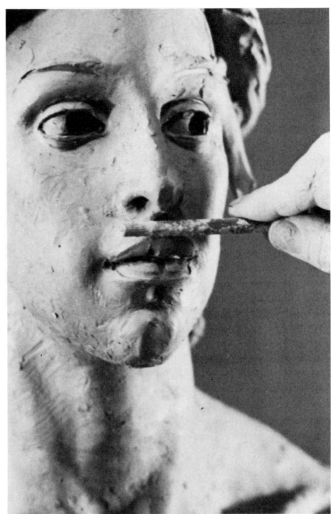

132. This time the dowel he rolls over the contours of the face is the end of a plaster tool.

133. He accentuates the curve of the upper lip by rolling the plaster tool into it.

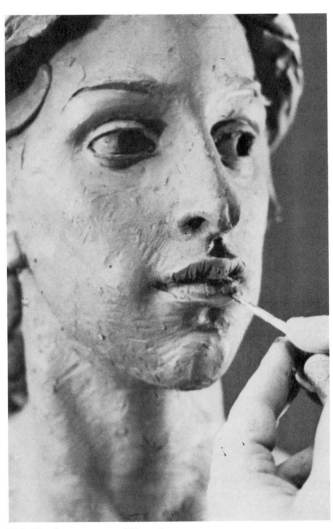

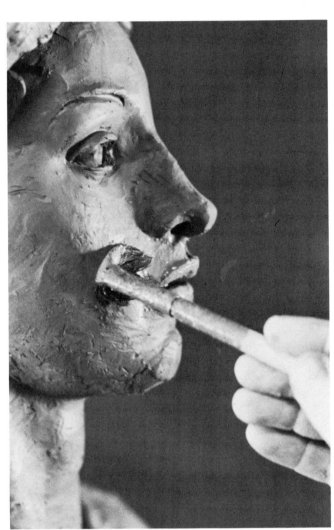

134. He draws a small brush up and down over the lips to indicate their crease pattern.

135. Now he picks up a larger brush, and dipping it into water, swirls it over the surface.

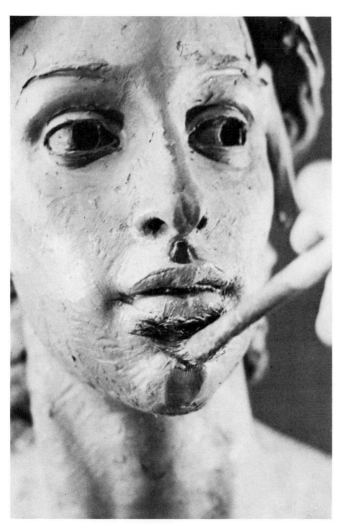

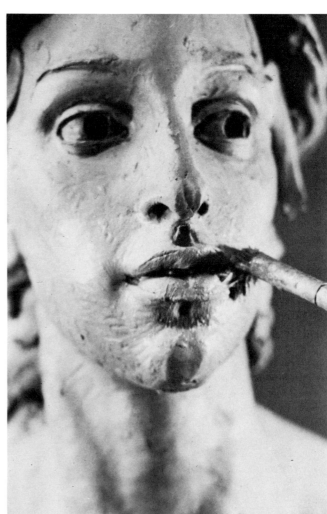

136. He works the hairs into the hollow beneath the lower lip.

137. And here into the corners of the mouth.

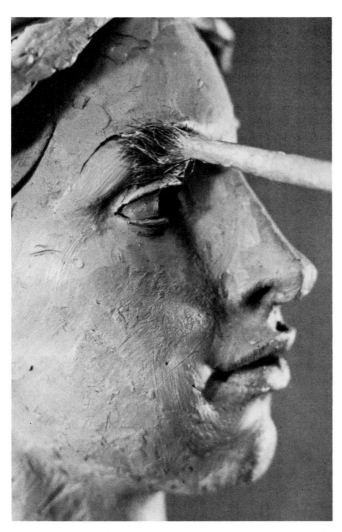

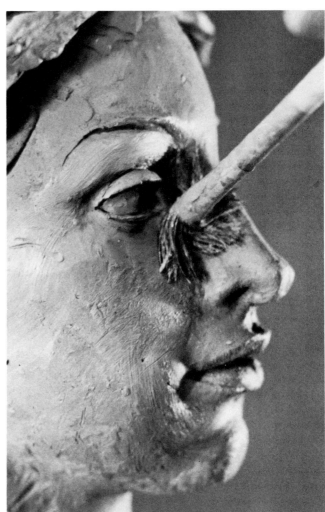

138. He moves the brush up to the eyes.

139. And works it into the hollow between eye and nose.

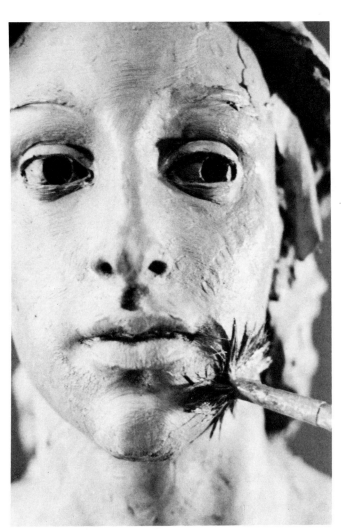

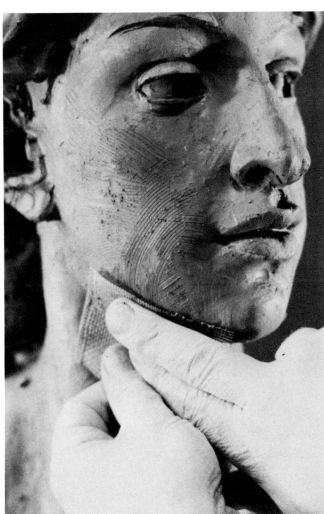

140. He textures and blends the whole facial surface in this way.

141. Now, drawing a piece of wire-mesh screen over the surface, Lucchesi further defines the forms of the face.

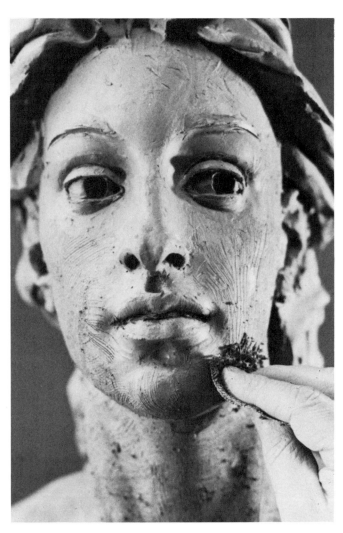

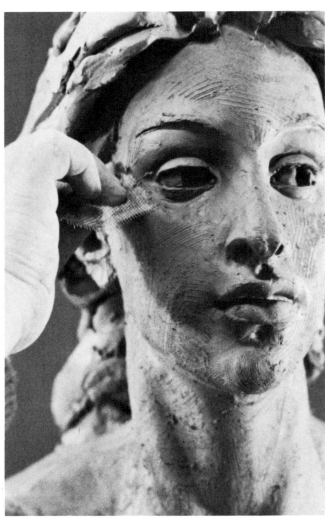

142. He carves into the face with the screen, shaving away excess clay.

143. Here Lucchesi carves and shapes the temple area with the screen.

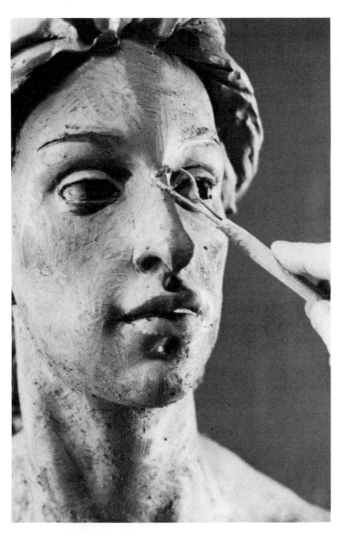

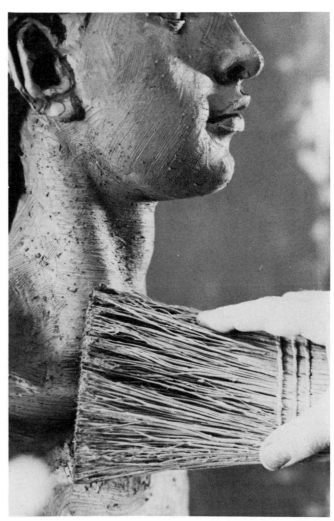

144. Going back to the wire-end tool, Lucchesi gently textures the surface all over, shaving away clay in minute amounts.

145. To blend the entire surface, Lucchesi draws a whisk broom back and forth over the clay, sometimes brushing against the forms and sometimes pressing the bristles against the clay and "carving" in the direction of the forms.

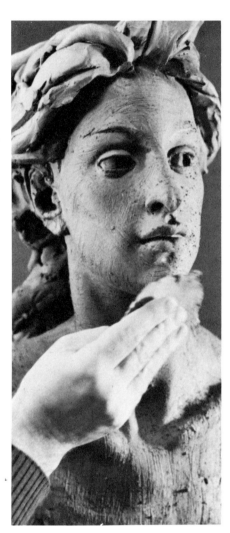

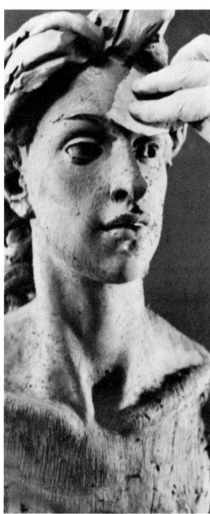

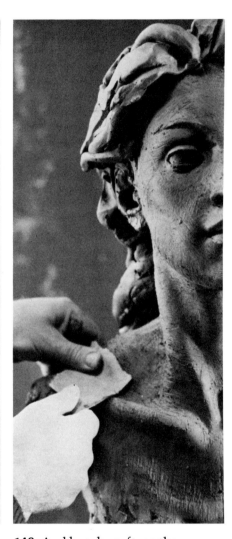

146. Now, to smooth the surface, he wipes a piece of cardboard over the clay.

147. Here he smooths the brow.

148. And here he softens the collarbone.

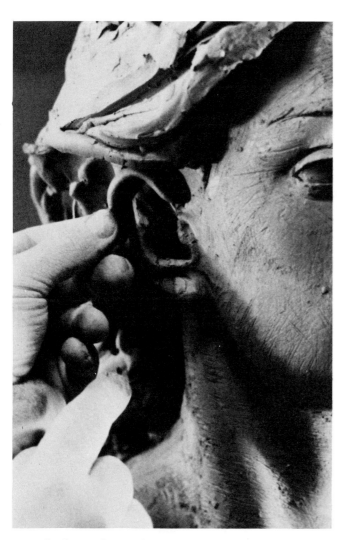

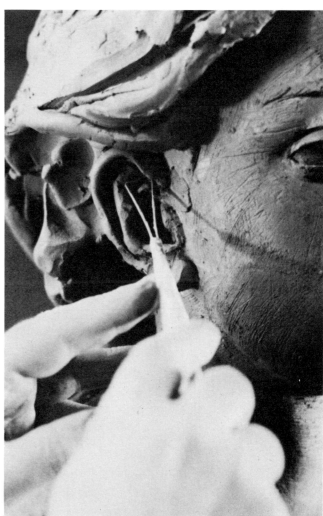

149. The basic shape of the ear has already been roughed in. Lucchesi again positions a coil of clay at the top, where the edge turns over.

150. With a wire-end tool, he carves more clay out of the interior of the ear.

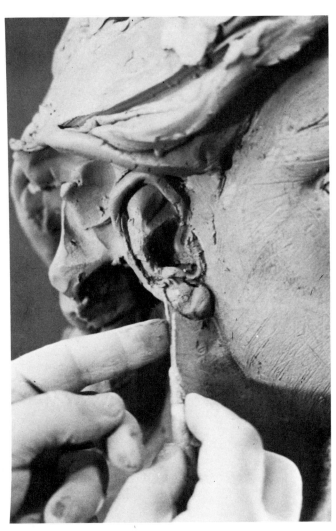

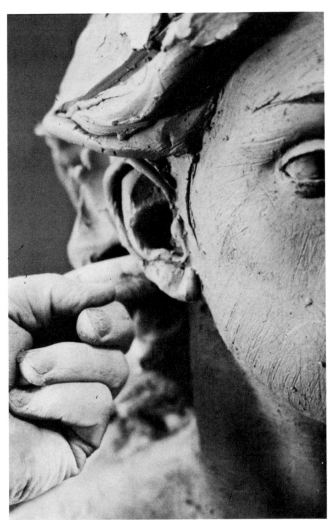

151. He defines the forms of the ear with a wire-end tool.

152. Here he pushes out the ear from behind, to accentuate its curve as seen from the front.

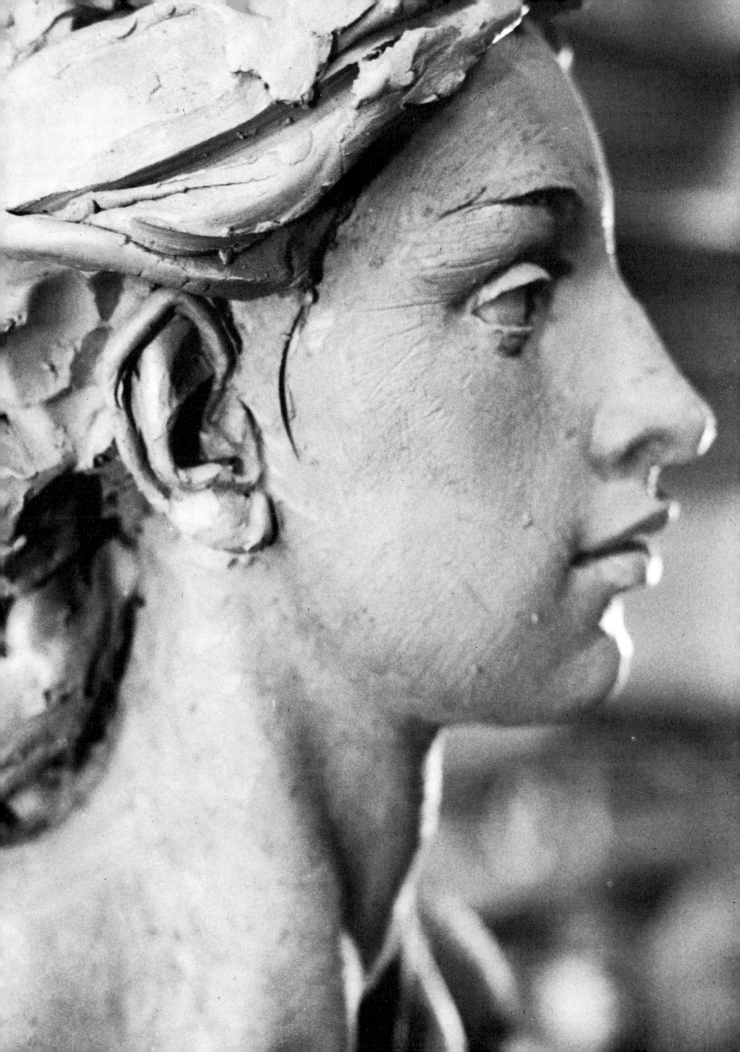

112

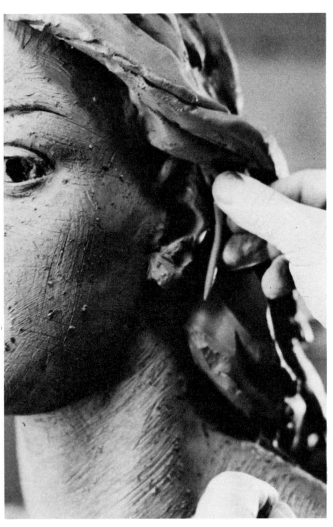

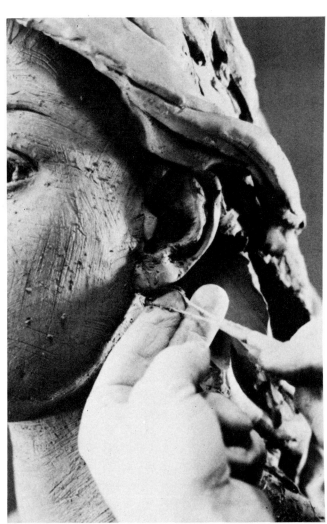

153. Moving around to the other ear, Lucchesi adds a coil of clay to form its outer edge.

154. Here he carves in behind the ear with a wire-end tool.

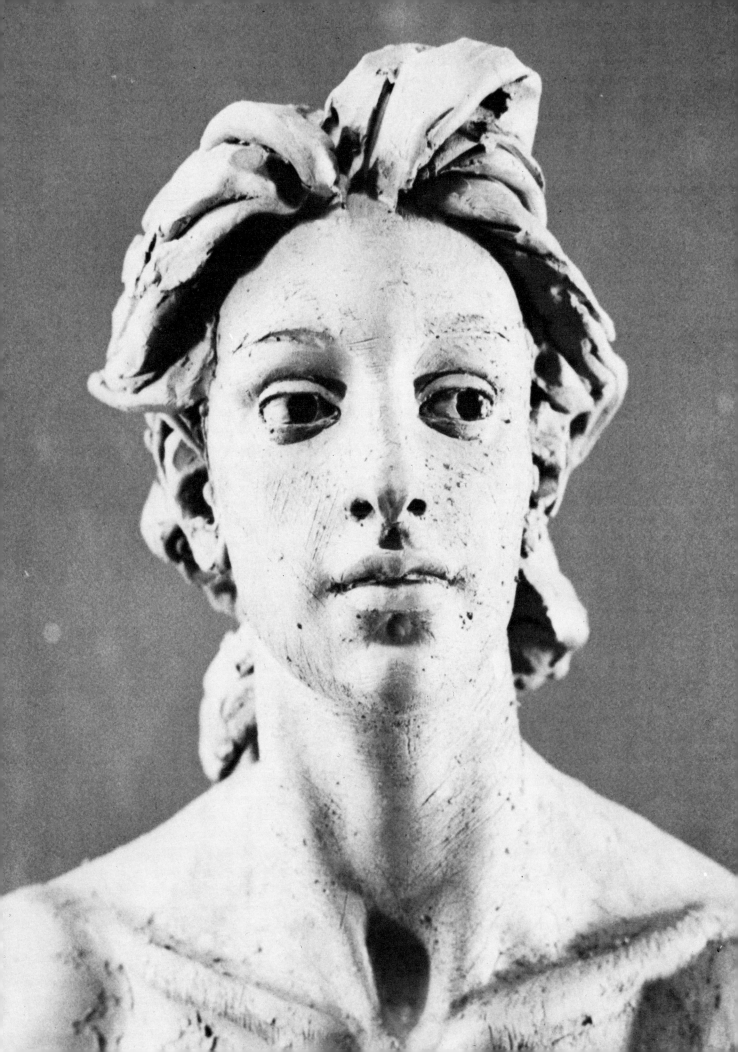

MODELING
THE HAIR

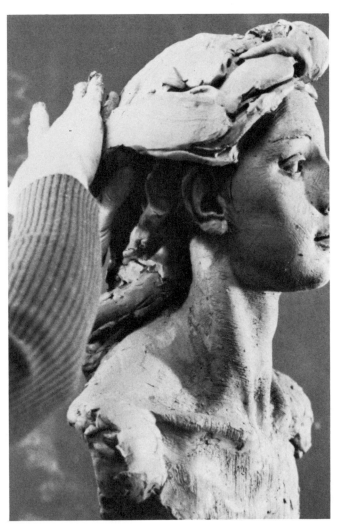

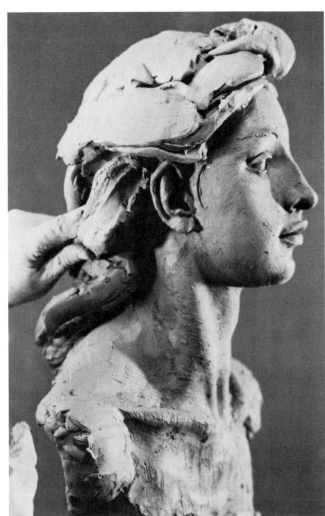

155. Now Lucchesi moves back to the hair, sweeping it into shape with the heel of his hand.

156. He pinches and bends the individual hair masses.

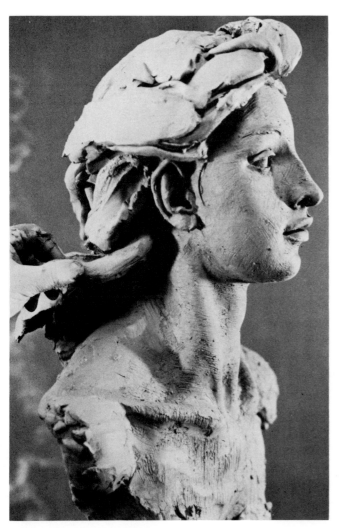 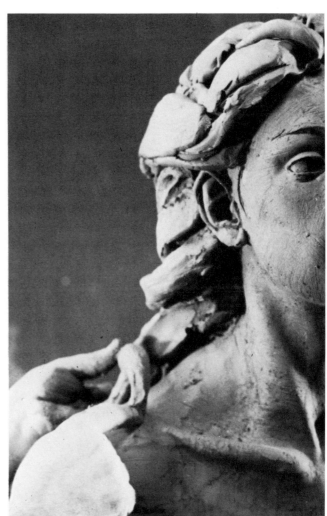

157. He adds more clay coils to fill in empty spaces.

158. He bends and shapes each coil as he works.

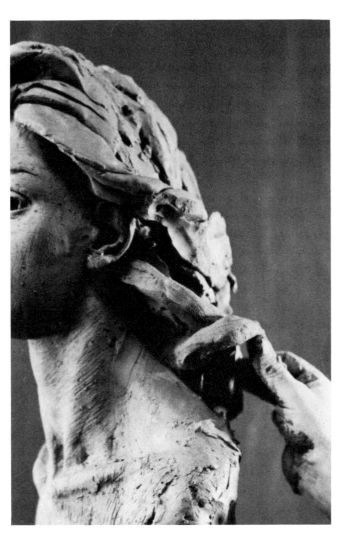

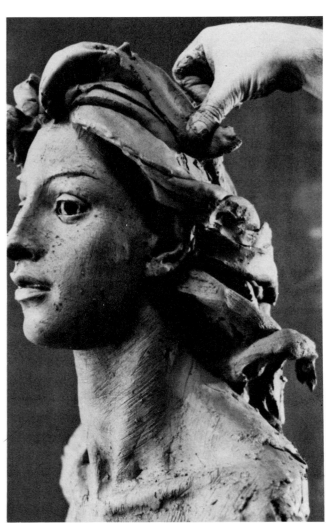

159. He builds up the hair mass coil by coil.

160. He adds clay to the ends where necessary.

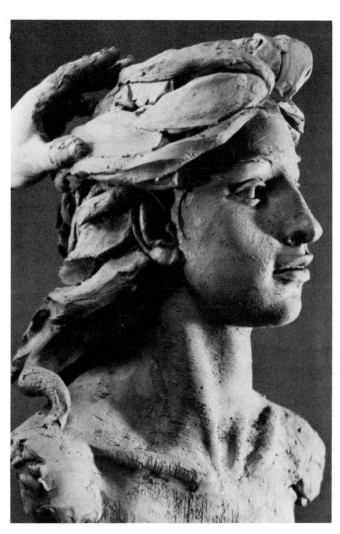

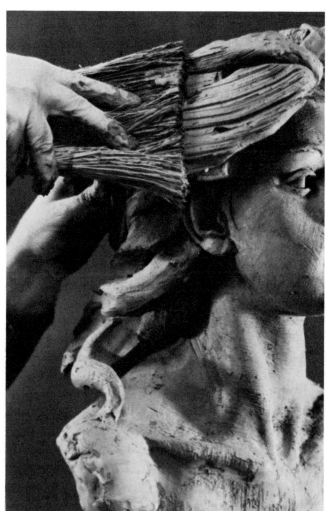

161. Here he draws his thumb along the coils to push down the clay.

162. With a firm, steady pressure, he pulls a whisk broom over the hair masses.

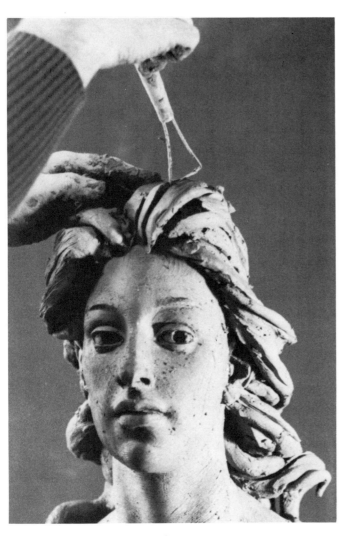

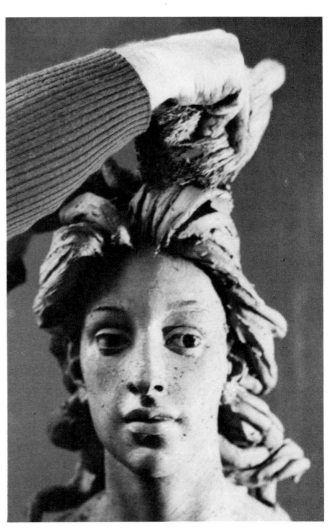

163. Here he accentuates the separate strands of hair with a large wire-end tool.

164. Taking up the whisk broom again, he "brushes" the hair in the direction it grows.

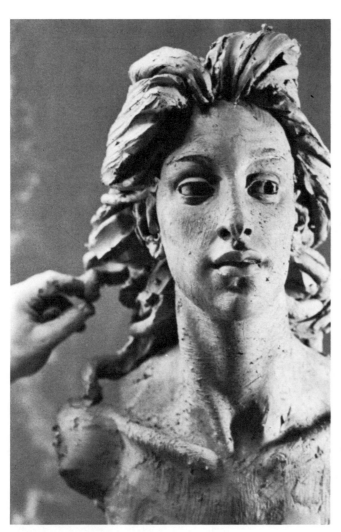

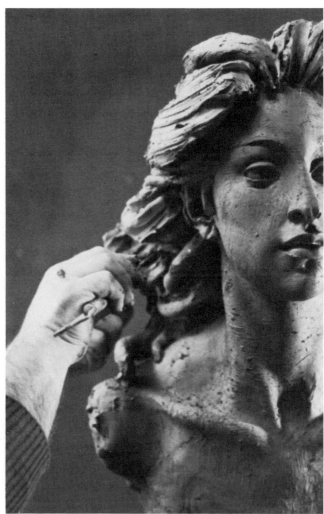

165. He pinches and shapes the tendrils.

166. To sharpen the forms, Lucchesi carves into the tendrils with a large wire-end tool.

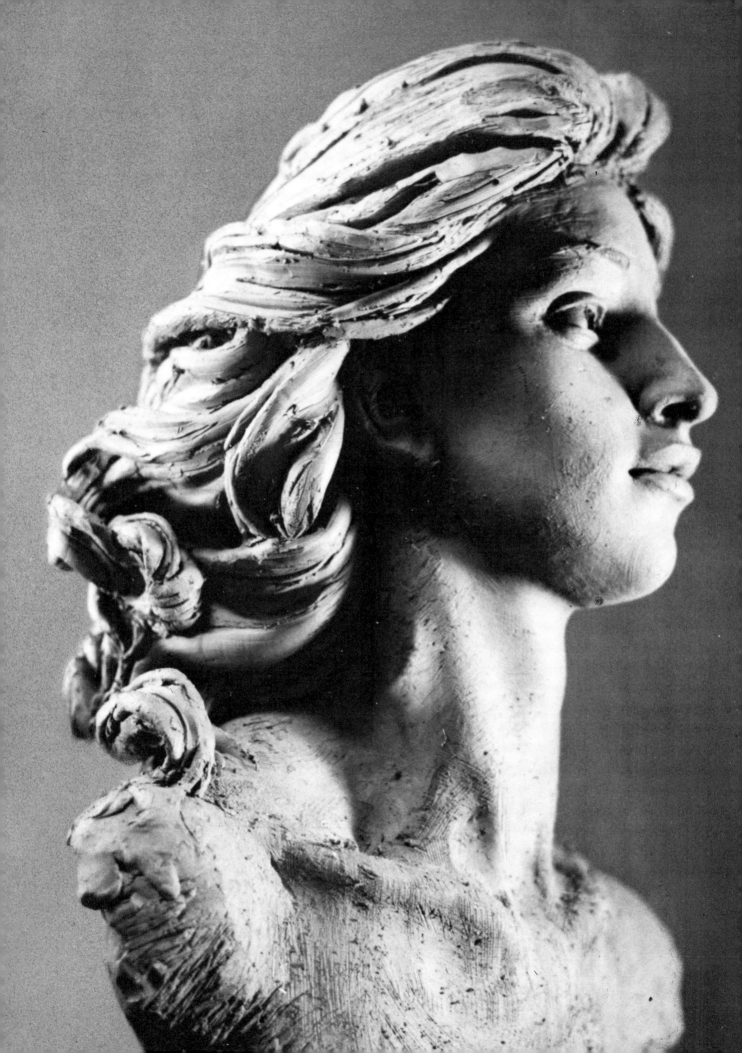

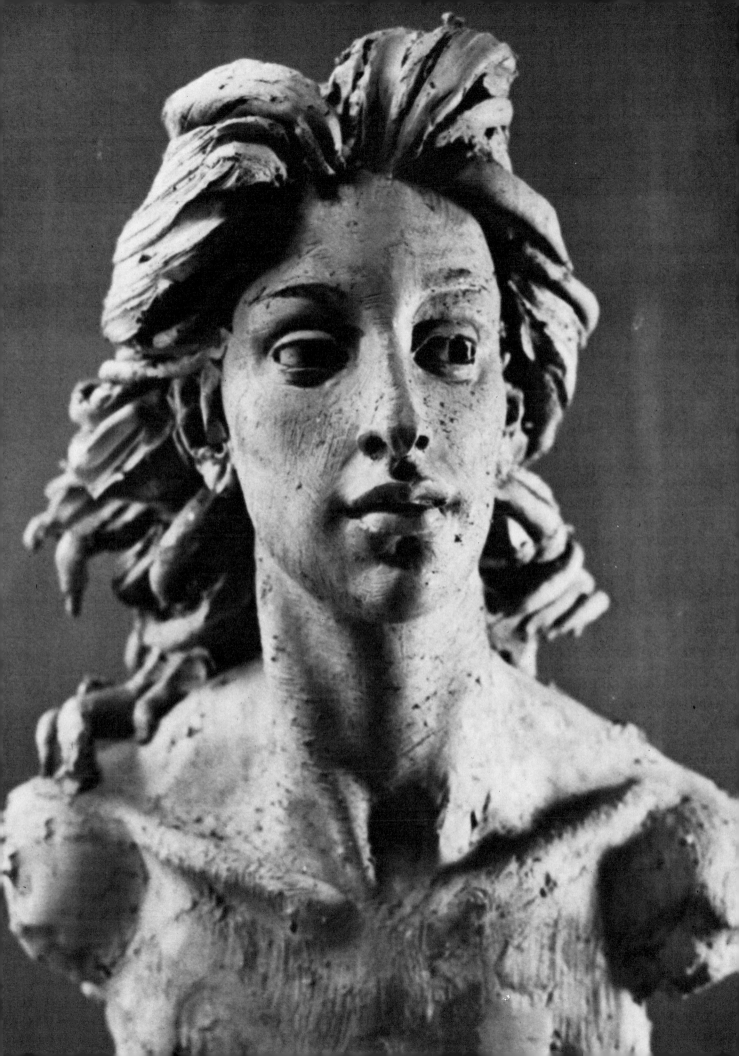

SHARPENING
THE SURFACE

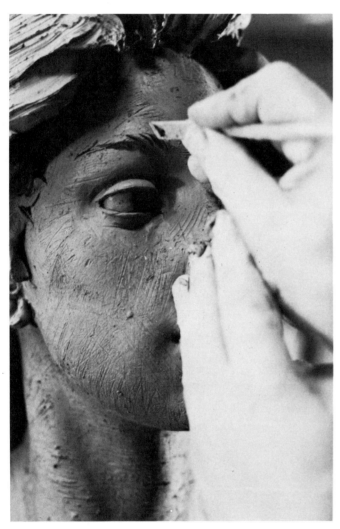

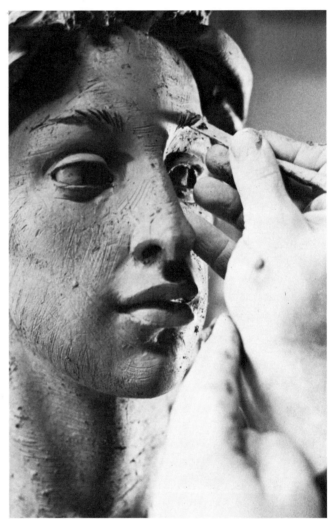

167. To define the eyebrows, Lucchesi presses the flat end of a modeling tool into the clay.

168. These indentations indicate the direction of the hair growth and give "color" to the eyebrows.

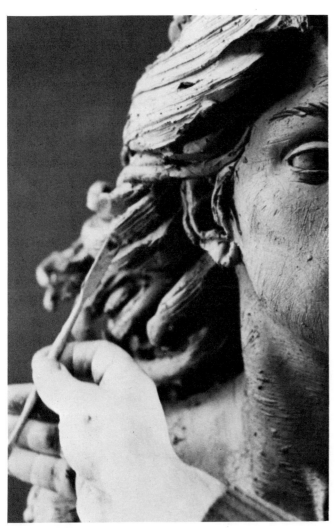

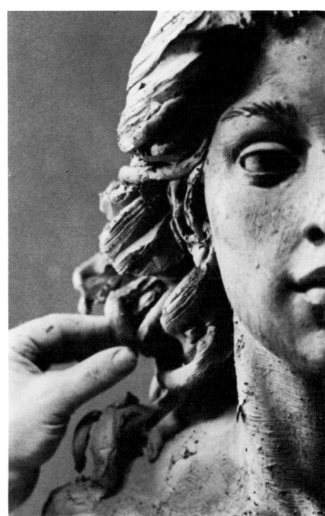

169. Now he sharpens up the modeling in the hair with a plaster tool.

170. Again, he arranges and rearranges the tendrils.

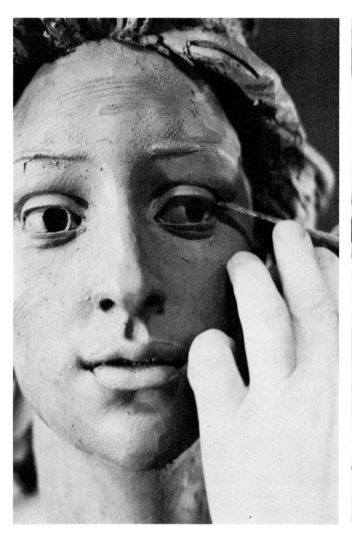

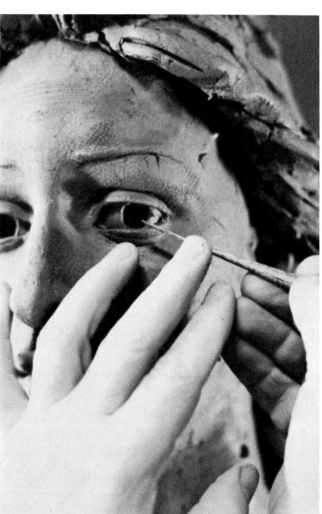

171. Lucchesi has gone over the entire surface with a wet brush to smooth and blend the clay. Notice that the eyebrow definition has disappeared. Here, using a plaster tool, Lucchesi accents and darkens the crease of the upper lid.

172. He cleans out the dark iris and refines the edge so that it will catch the light.

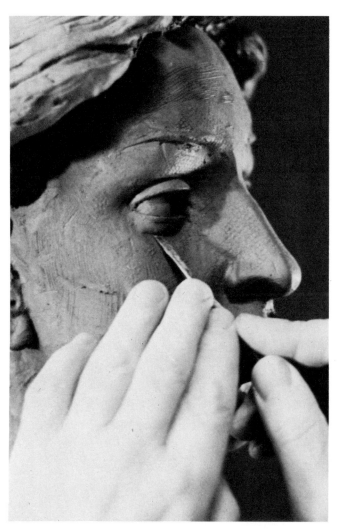

173. Now he moves down, running the plaster tool along the underside of the lower lid to emphasize the crease.

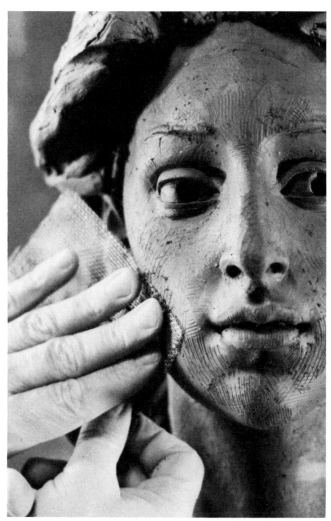

174. Again using a fine-mesh screen, Lucchesi shaves away excess clay.

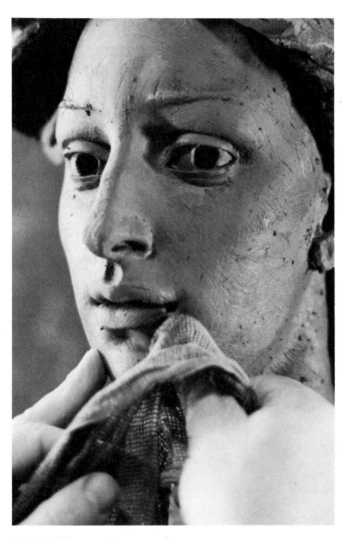

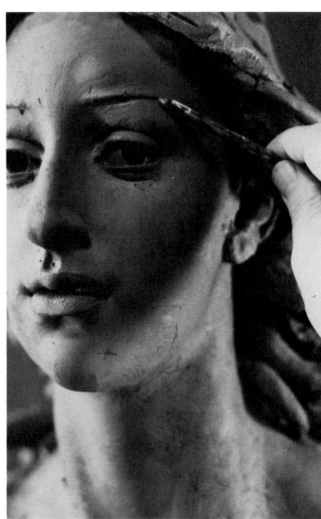

175. He blots and presses the surface with a piece of fine burlap.

176. Here he runs a plaster tool along the underside of the eyebrow to accentuate the line

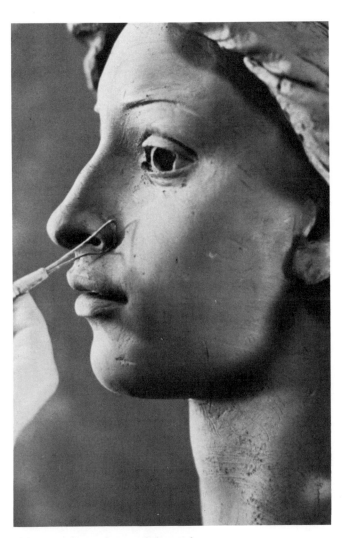

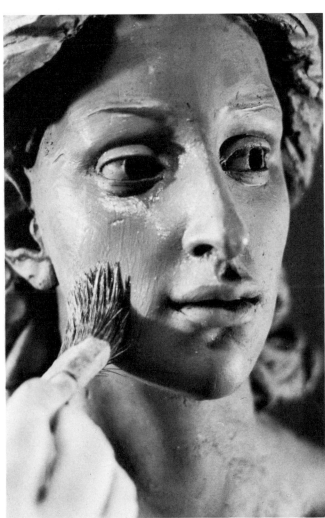

177. He refines the modeling of the nostril with a wire-end tool.

178. He wipes a bristle brush loaded with water over the face to smooth the surface.

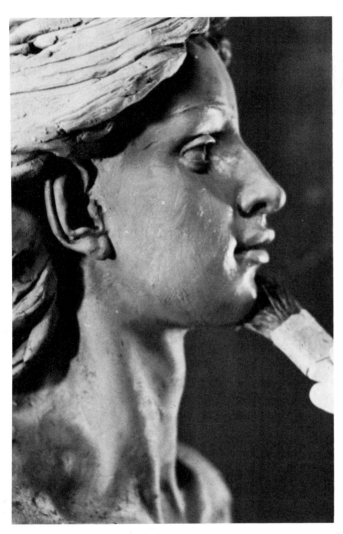

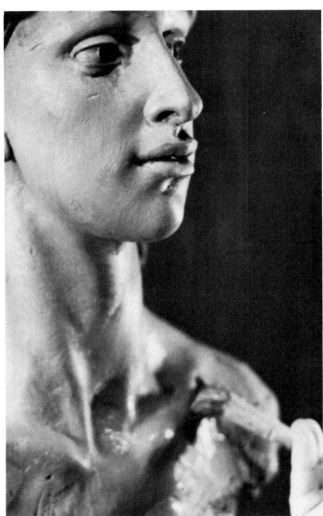

179. Here he uses a back-and-forth motion of the wet brush.

180. He moves the brush down to smooth and blend the clay of the shoulder area.

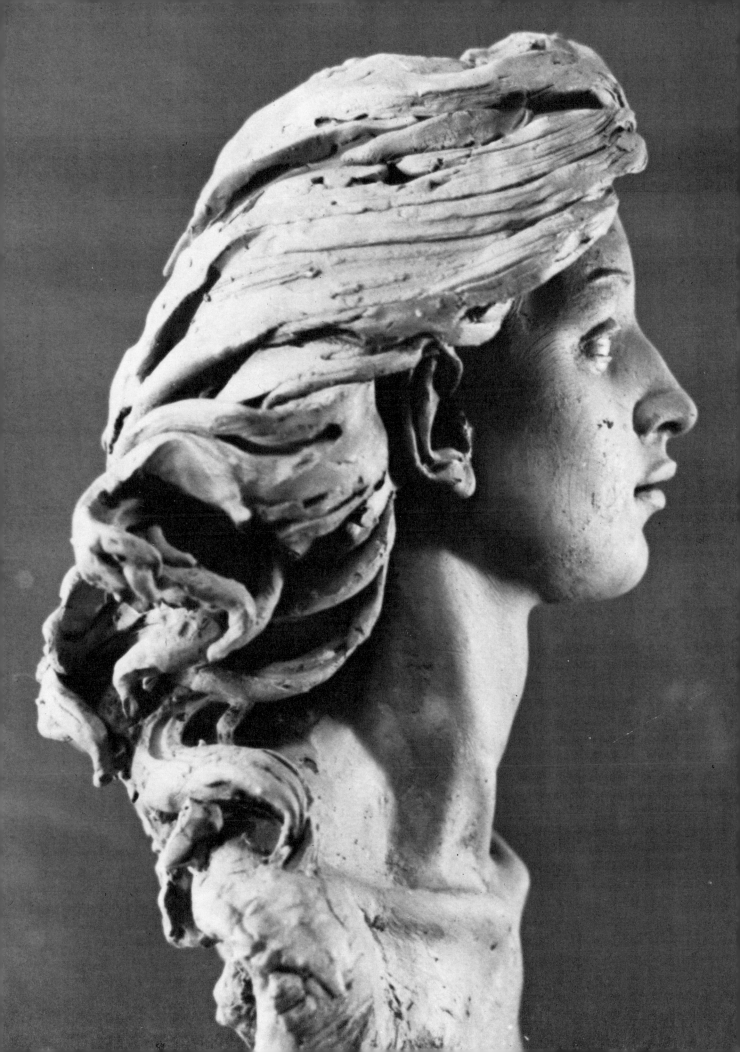

REFINING
THE HAIR

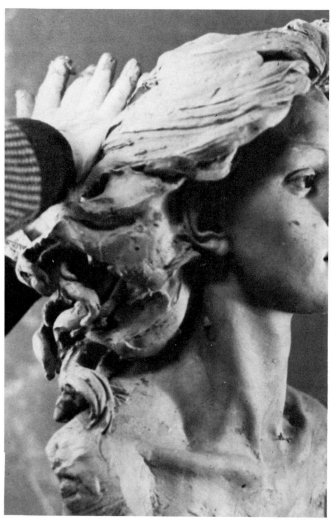

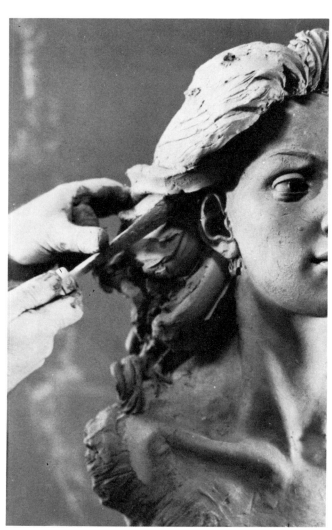

181. Again, with the heel of his hand, Lucchesi sweeps in the broad planes of the hair.

182. Then he pulls out individual strands with a plaster tool.

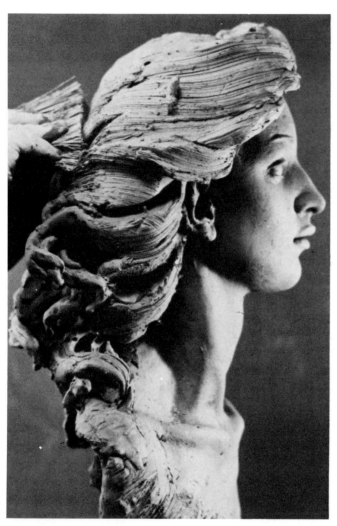

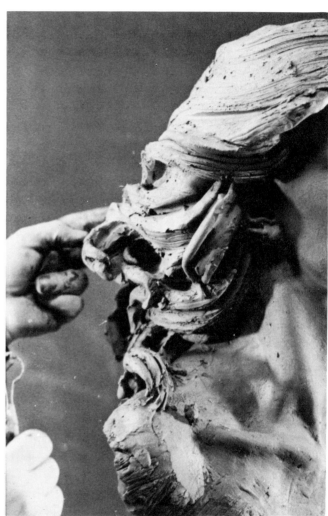

183. Again he "brushes" the hair vigorously with the whisk broom.

184. He picks up the ends of the hair and curls them, trying out different positions.

132

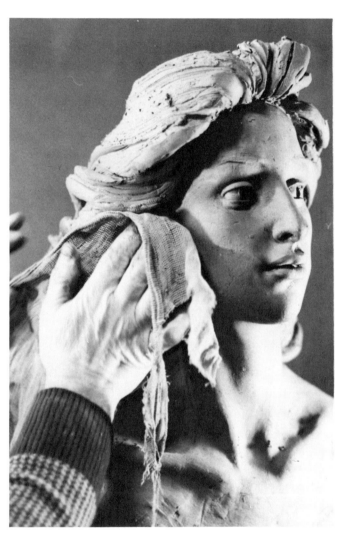

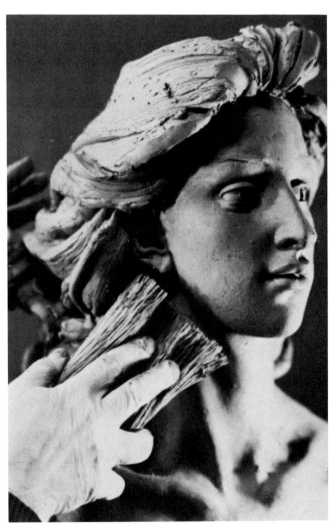

185. Now he wipes the hair with a piece of cheesecloth, following the direction of its movement.

186. Again, Lucchesi runs the whisk broom over the hair.

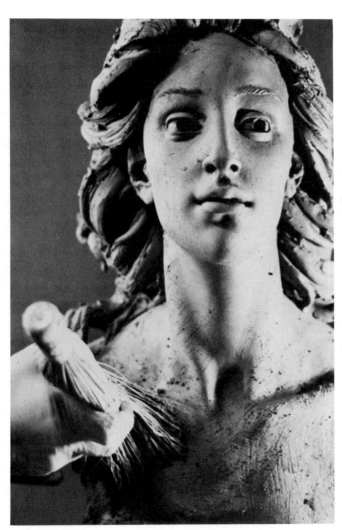

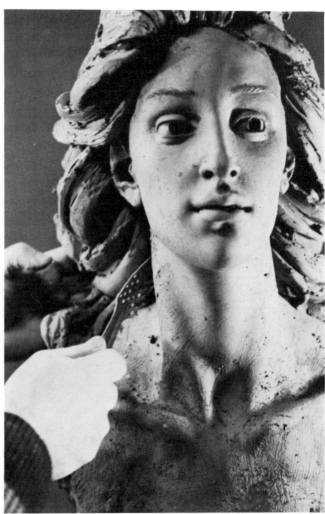

187. Then he moves it down to the bust.

188. He carves away clay with a serrated plaster tool to make dark undercuts in the hair.

134

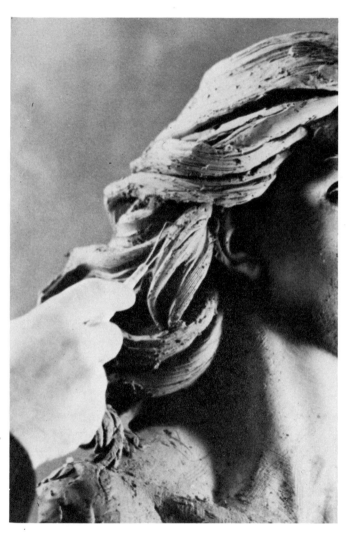 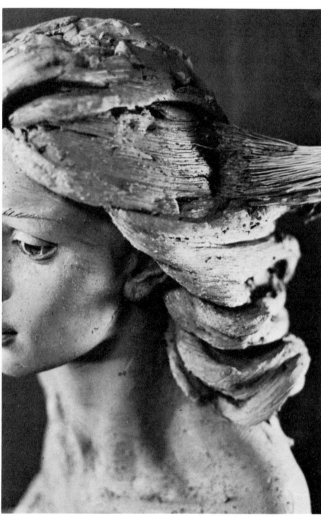

189. With a wire-end tool, he incises strands of hair into the larger mass.

190. More brushing, here seen from the top.

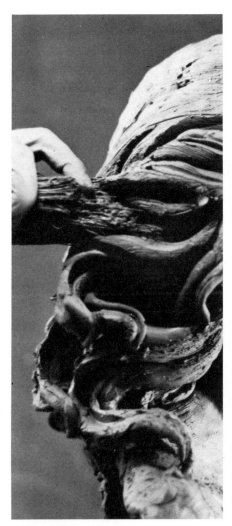

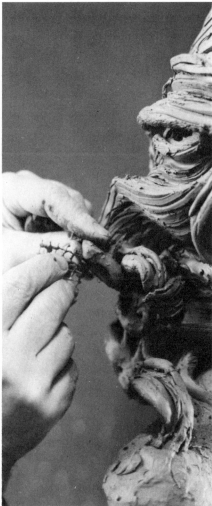

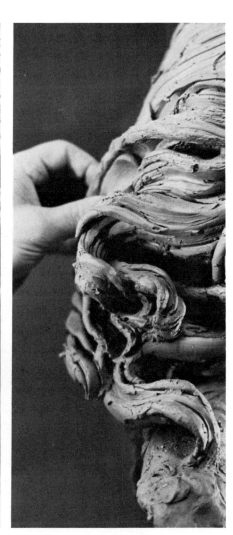

191. Here Lucchesi digs the bristles of the whisk broom into the undercuts of the hair mass.

192. With a small piece of very coarse wire screen, Lucchesi cuts sharp accents and dark areas into the hair to give it texture and depth.

193. He adds clay to fill in undercuts that are too deep.

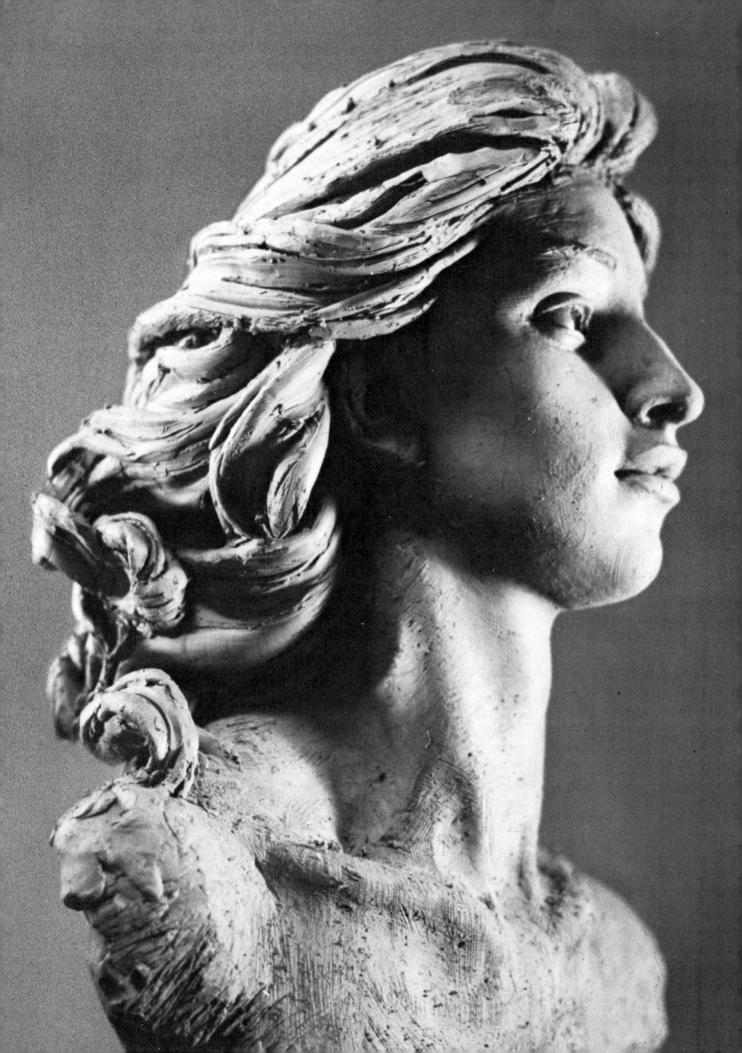

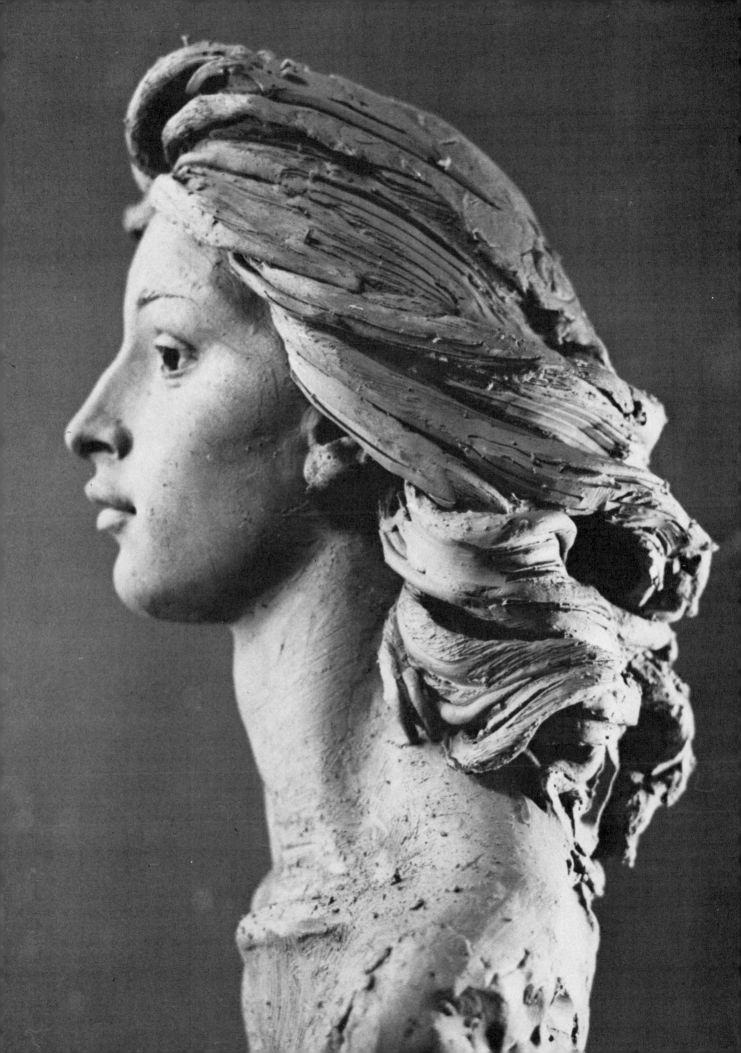

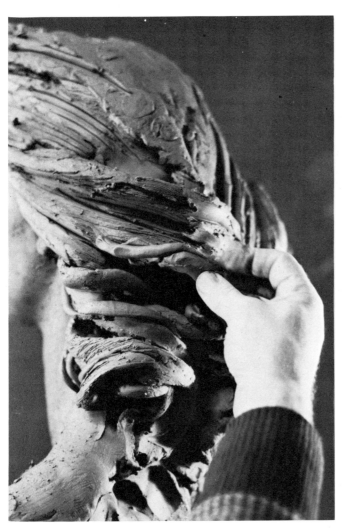

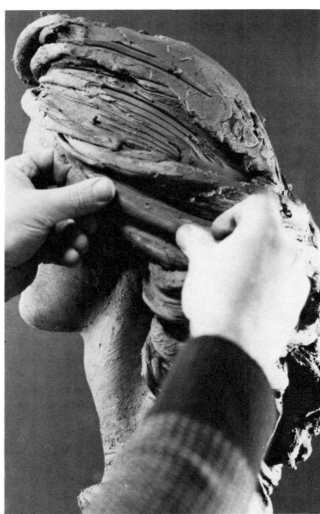

194. Here Lucchesi adds more clay to the hair, bending and shaping each coil.

195. Here he builds up the sides of the hair with additional coils of clay.

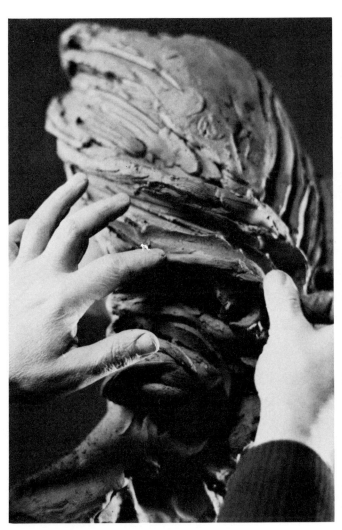

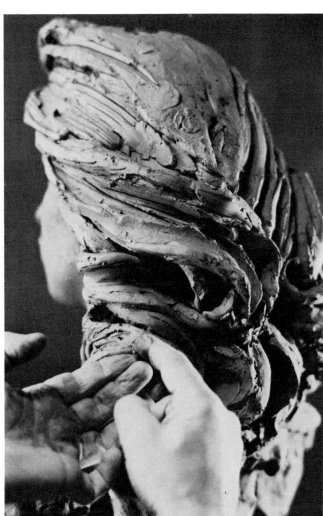

196. He blends the clay with his fingers, modeling each coil separately.

197. Notice how Lucchesi cradles each tendril as he shapes it.

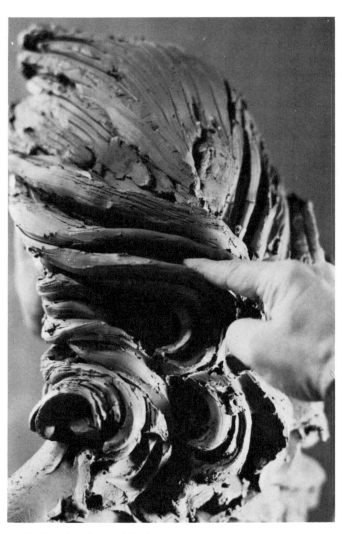

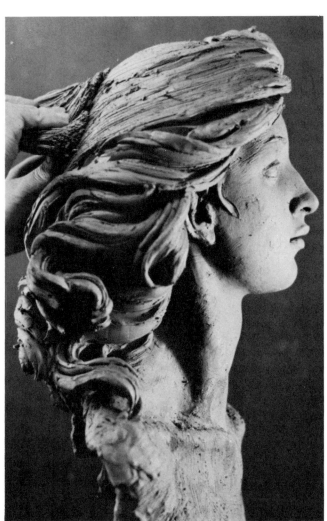

198. Here he draws his finger firmly along the newly added hair to define its movement.

199. He brushes the hair again.

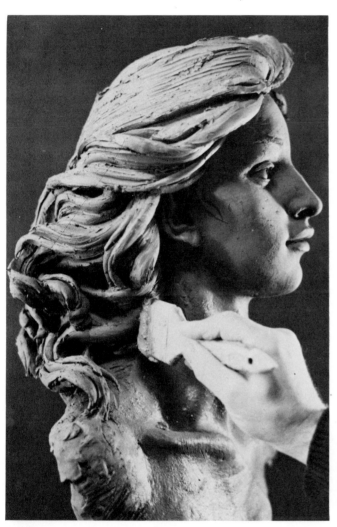

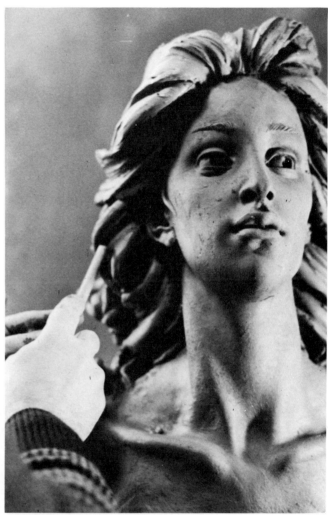

200. Now he uses a very wet bristle brush to blend and soften the forms.

201. With the end of a wooden dowel, Lucchesi redefines the divisions between the masses of hair.

REFINING
THE EARS

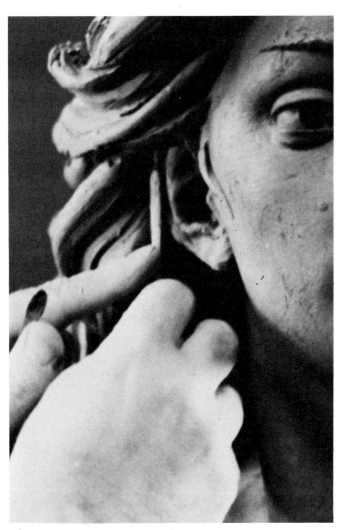

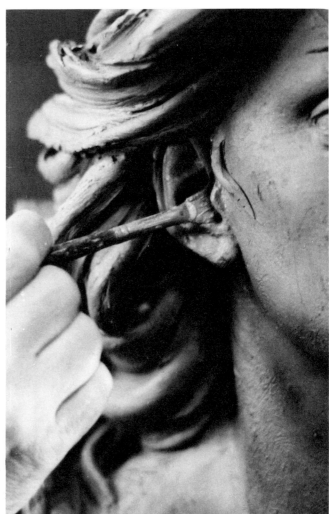

202. Lucchesi presses the shank of a modeling tool against the side of the ear, gently rolling it back and forth.

203. With a wet paintbrush, he goes into the inside forms of the ear to blend and smooth the clay.

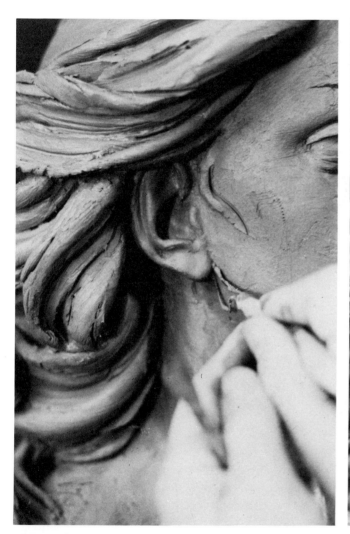

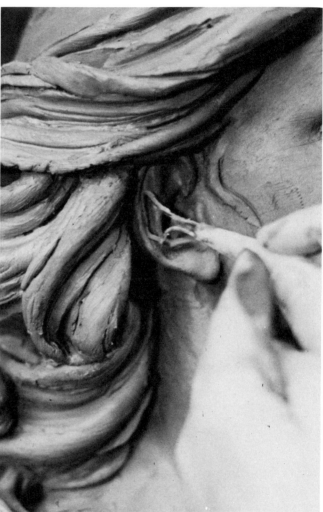

204. He draws a wire-end tool up around the earlobe to give it a clean line.

205. Then he brings the tool up to clean out the edge of the ear where it curls over.

REFINING
THE LIPS

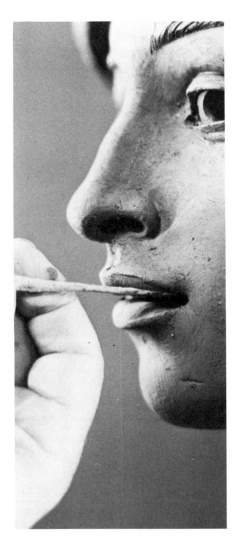 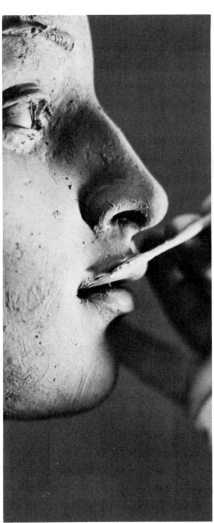 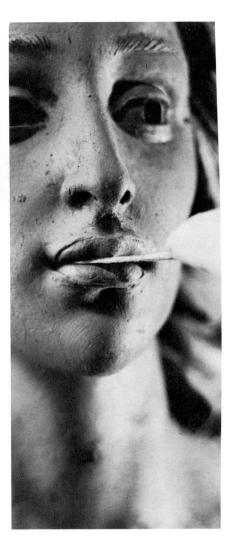

206. With a pointed plaster tool, Lucchesi deepens the indentation at the corners of the mouth.

207. He presses the tool just below the lip line to give the lips a sharp, light-catching edge.

208. He opens the lips by deepening the space between them.

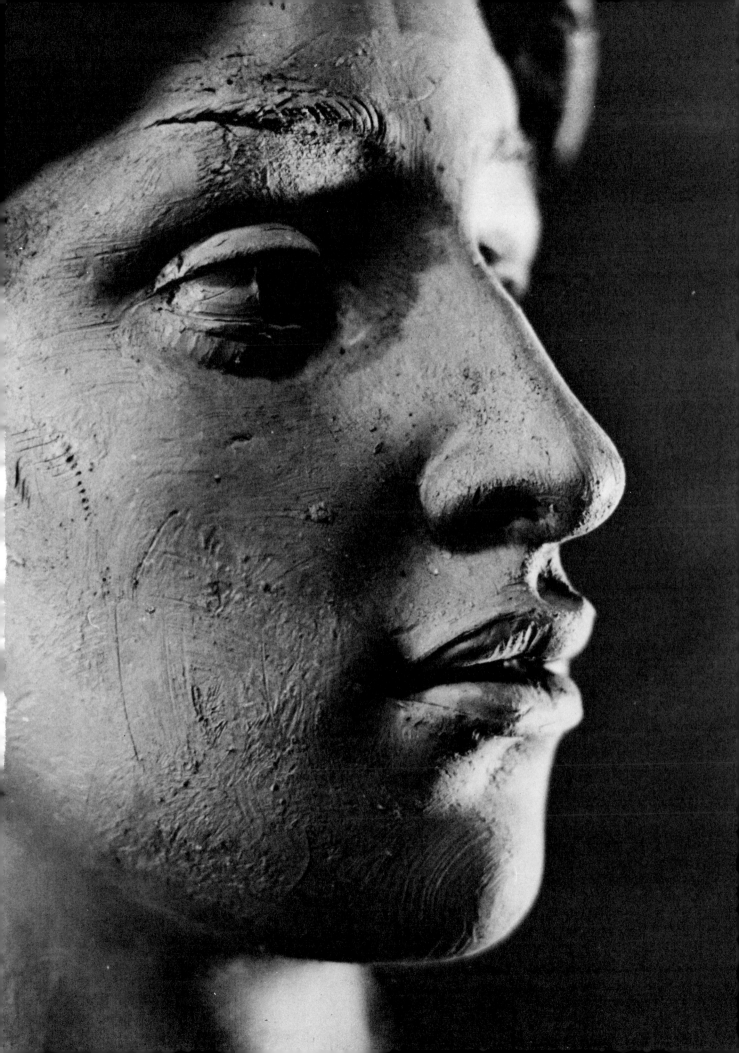

FINISHING
TOUCHES

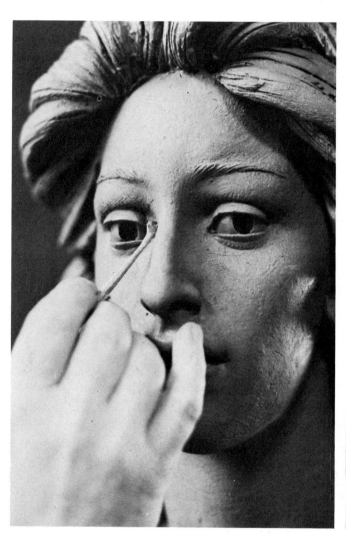

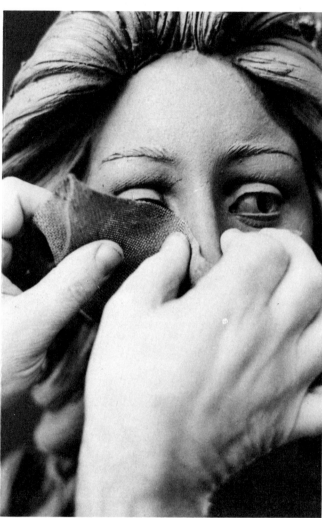

209. Here, using quick, light touches, Lucchesi gently shaves away clay with a plaster tool.

210. He presses a piece of flexible fine-mesh screen into the clay to give it a fine-grained texture, here at the side of the nose.

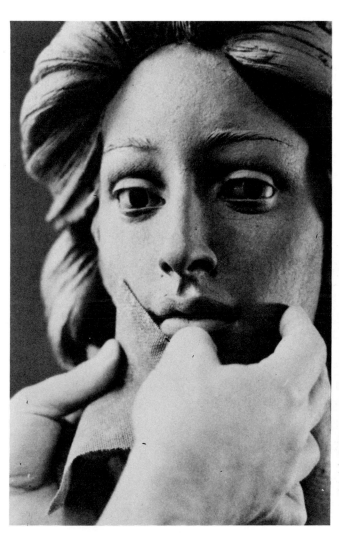

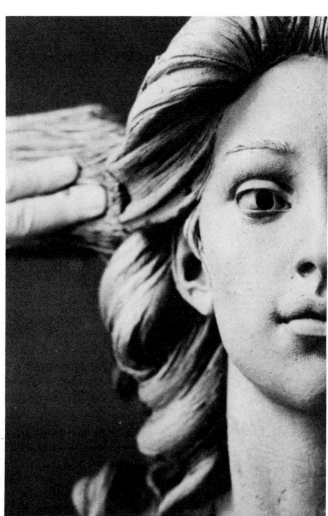

211. And here in the mouth area.

212. Now he moves back to the hair, redefining the texture with the whisk broom.

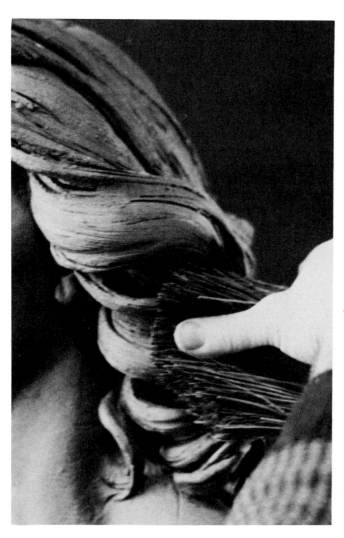

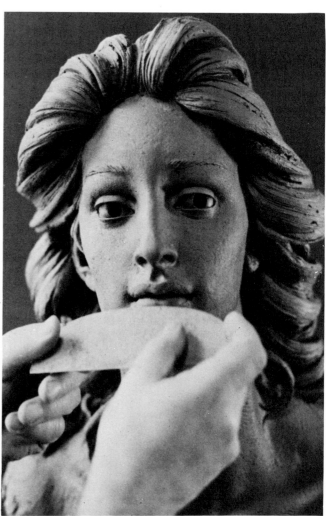

213. He pushes his thumb against the bristles, forcing them into the low-lying areas of hair.

214. Here Lucchesi presses a flexible plastic palette against the lower lip to emphasize its sharp edge.

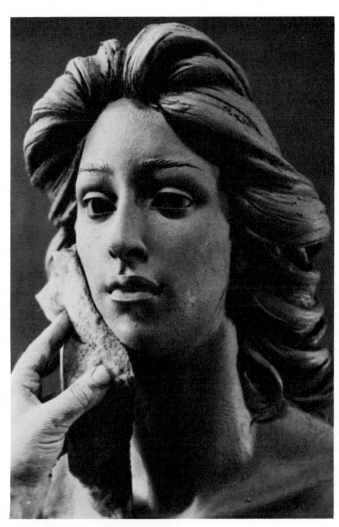

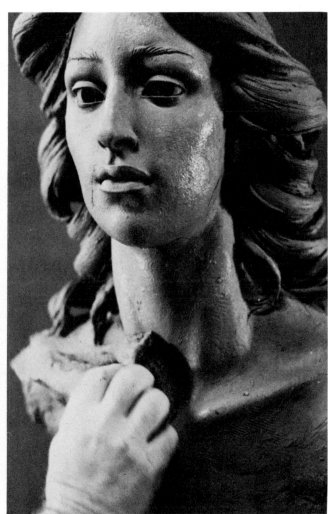

215. Lucchesi wipes a wet sponge over the entire piece, blotting the moisture as well as wiping, to get a grainy fleshlike effect.

216. He brings the sponge down over the neck and shoulders, blotting gently as he goes.

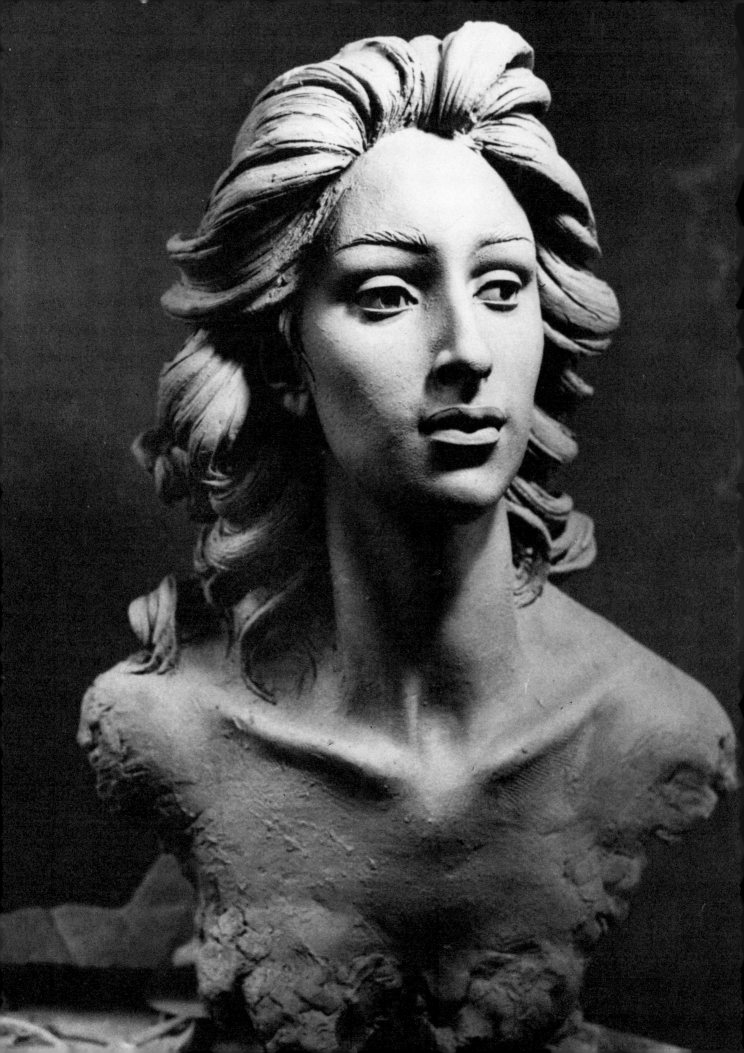

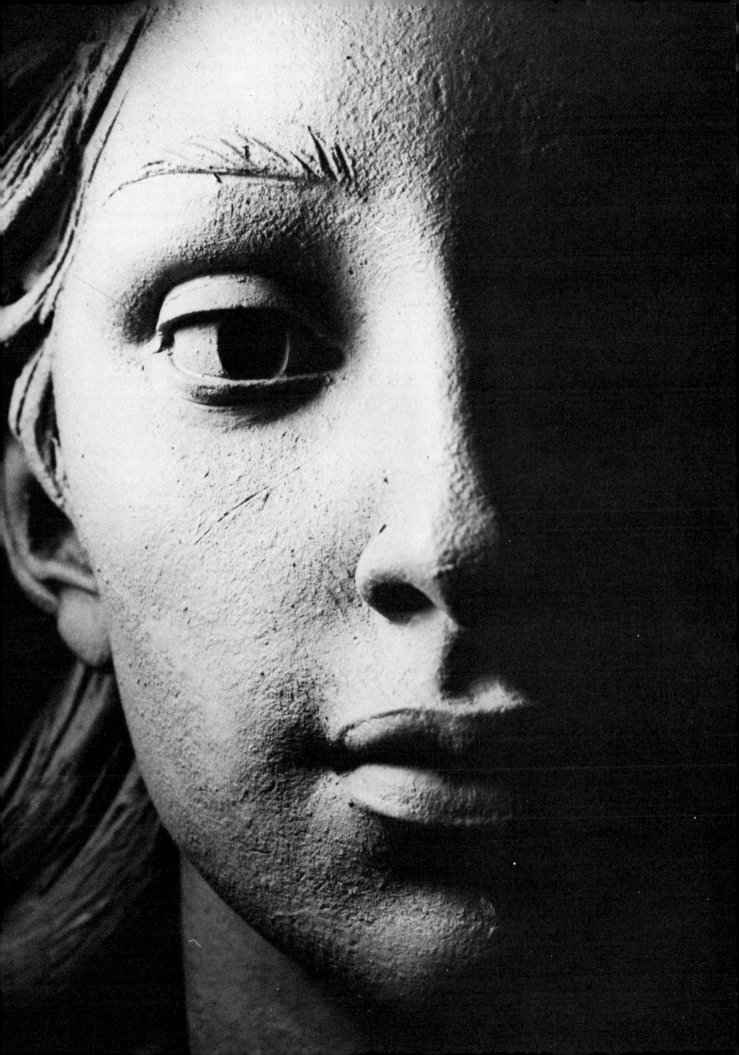

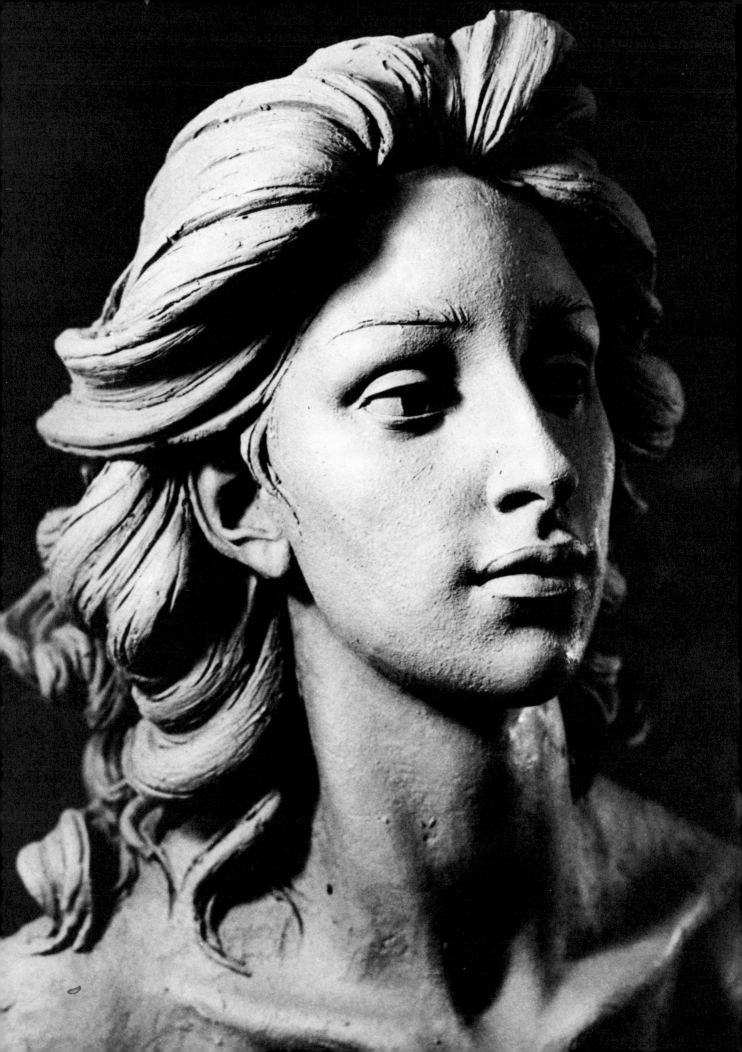

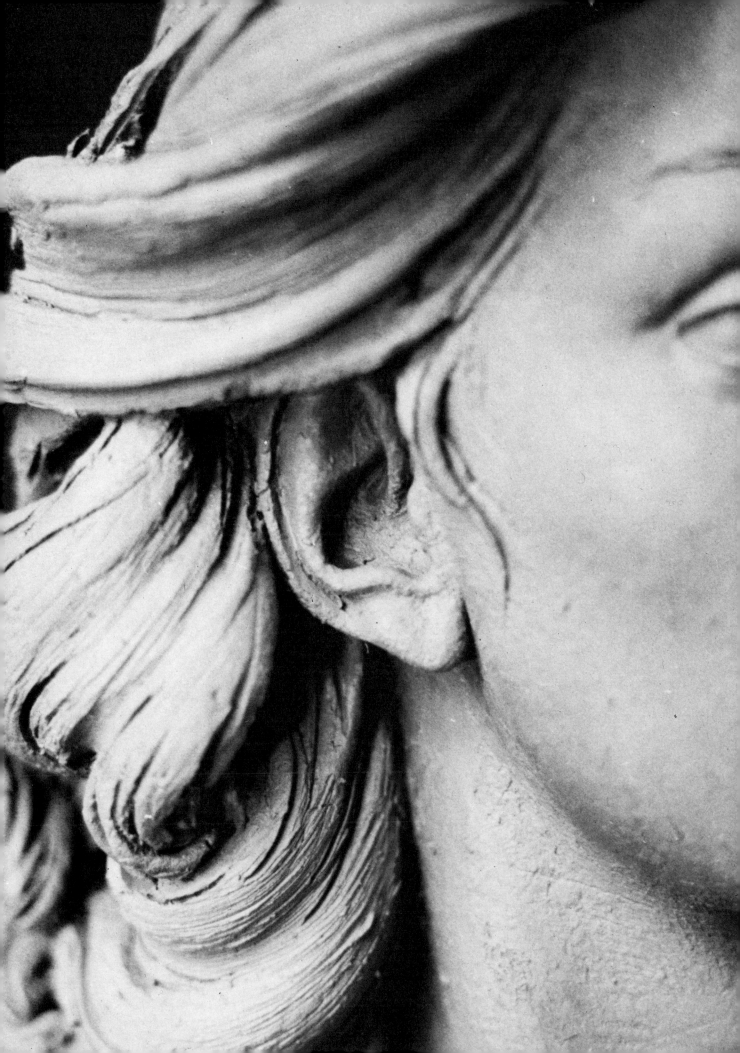

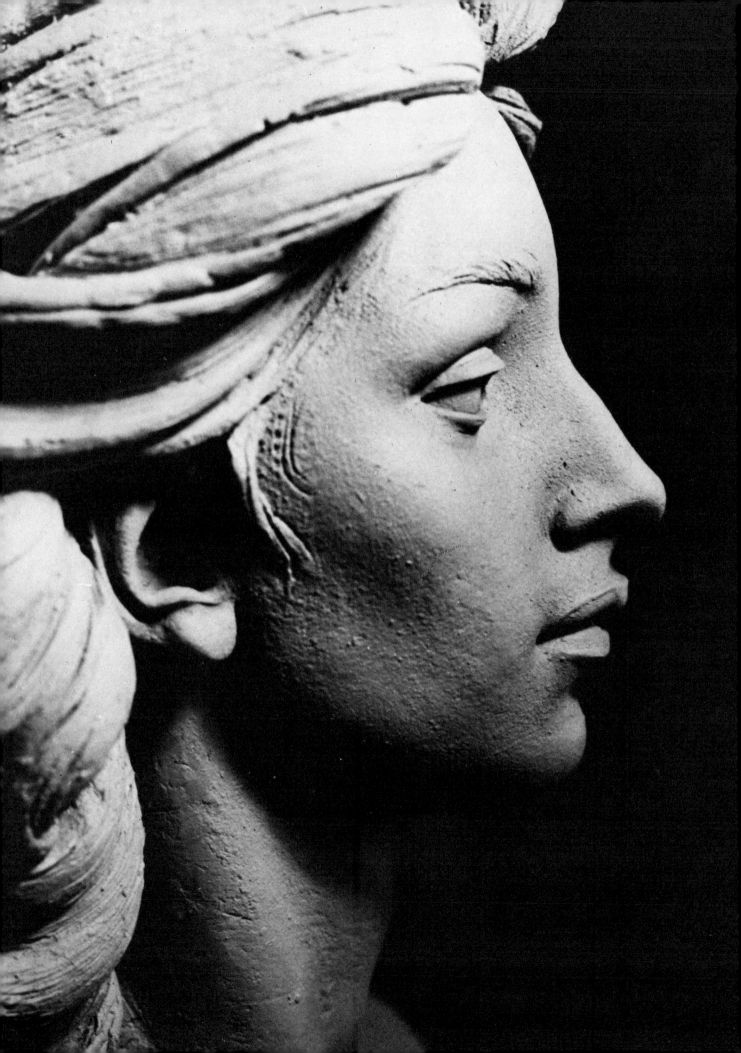

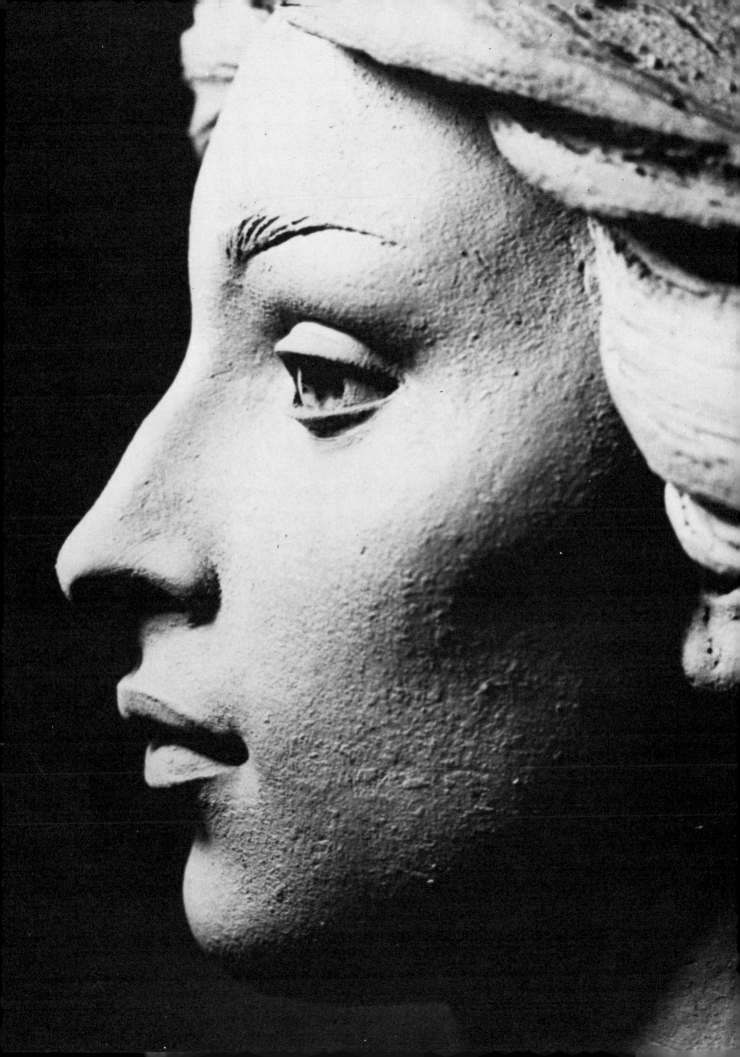

SUPPLIERS

The suppliers listed on this page are all in the New York City metropolitan area. For suppliers in other parts of the country, consult your local Yellow Pages under "Pottery Equipment and Supplies," "Sculptors," and "Sculptors' Equipment and Supplies."

SCULPTURE SUPPLIES

These suppliers stock everything required by the sculptor and will send a mail-order catalog upon request:

Sculpture Associates, Ltd.
114 East 25 Street
New York, N.Y. 10010

Sculpture House
38 East 30 Street
New York, N.Y. 10016

Sculpture Services
9 East 19 Street
New York, N.Y. 10003

Stewart Clay Company, Inc.
P.O. Box 18
400 Jersey Avenue
New Brunswick, New Jersey 08902

For clay only:

Jack D. Wolfe Company, Inc.
724 Meeker Avenue
Brooklyn, New York 11222

For a complete line of pottery supplies:

Baldwin Pottery, Inc.
540 La Guardia Place
New York, N.Y. 10012

FIRING SERVICES

For firing opportunities in your area consult your local pottery suppliers, craft schools or groups, or art departments of schools. It may take a bit of asking around before you find someone willing to fire your work for you. In the New York area two well-established firing services are:

Baldwin Pottery, Inc.
540 La Guardia Place
New York, N.Y. 10012

Studio Workshop
3 West 18 Street
New York, N.Y. 10010

CASTING AND MOUNTING

Gino Giannaccini Sculpture
 Casting
120 St. Mark's Place
New York, N.Y. 10009

Rocca-Noto Sculpture Studio, Inc.
18 West 22 Street
New York, N.Y. 10010

Sculpture Associates Ltd.
114 East 25 Street
New York, N.Y. 10010

Sculpture Casting
155 Chrystie Street
New York, N.Y. 10002

Sculpture House
38 East 30 Street
New York, N.Y. 10016

Sculpture Services
9 East 19 Street
New York, N.Y. 10003

BRONZE CASTING FOUNDRIES

Excalibur Bronze Sculpture
 Foundry
49 Bleecker Street
New York, N.Y. 10010

Joel Meisner & Company, Inc.
120 Fairchild Avenue
Plainview, New York 11803

Modern Art Foundry, Inc.
18–70 41st Street
Long Island City, New York 11105

Roman Bronze Works, Inc.
96–18 43rd Avenue
Corona, Queens
New York 11368

BRITISH SUPPLIERS

Sculpture Supplies:
Alec Tiranti
21 Goodge Place
London W1

Clay Supplies:
Anchor Chemical Co., Ltd.
Clayton
Manchester M11 4SR

Pottery Equipment:
Podmore Ceramics, Ltd.
105 Minet Road
London SW9 7UH

Potclays, Ltd.
Brickkiln Lane
Etruria, Staffordshire

Harrison Meyer, Ltd.
Meir, Stoke, Staffordshire

Bronze Casting:
A and A Sculpture Castings, Ltd.
1 Faive Street
London E14

INDEX

CASTING AND MOUNTING

Gino Giannaccini Sculpture
 Casting
120 St. Mark's Place
New York, N.Y. 10009

Rocca-Noto Sculpture Studio, Inc.
18 West 22 Street
New York, N.Y. 10010

Sculpture Associates Ltd.
114 East 25 Street
New York, N.Y. 10010

Sculpture Casting
155 Chrystie Street
New York, N.Y. 10002

Sculpture House
38 East 30 Street
New York, N.Y. 10016

Sculpture Services
9 East 19 Street
New York, N.Y. 10003

BRONZE CASTING FOUNDRIES

Excalibur Bronze Sculpture
 Foundry
49 Bleecker Street
New York, N.Y. 10010

Joel Meisner & Company, Inc.
120 Fairchild Avenue
Plainview, New York 11803

Modern Art Foundry, Inc.
18–70 41st Street
Long Island City, New York 11105

Roman Bronze Works, Inc.
96–18 43rd Avenue
Corona, Queens
New York 11368

BRITISH SUPPLIERS

Sculpture Supplies:
Alec Tiranti
21 Goodge Place
London W1

Clay Supplies:
Anchor Chemical Co., Ltd.
Clayton
Manchester M11 4SR

Pottery Equipment:
Podmore Ceramics, Ltd.
105 Minet Road
London SW9 7UH

Potclays, Ltd.
Brickkiln Lane
Etruria, Staffordshire

Harrison Meyer, Ltd.
Meir, Stoke, Staffordshire

Bronze Casting:
A and A Sculpture Castings, Ltd.
1 Faive Street
London E14

INDEX

Edited by Connie Buckley
Designed by Bob Fillie
Set in 11 point Trump Mediaeval